"FOR ME, THE ANSWER
IS ALWAYS IN THE GARDEN."

HOLLY HEIDER CHAPPLE

A LIFE IN FLOWERS

A LIFE IN FLOWERS

Lessons & Affirmations from the Garden

HOLLY HEIDER CHAPPLE

Publisher: BLOOM Imprint

Author: HOLLY HEIDER CHAPPLE

Editorial Director: DEBRA PRINZING

Creative Director: ROBIN AVNI

Designer: JENNY MOORE-DIAZ

Copy Editor: JUDITH H. DERN

Image Editor: HEATHER MARINO

Cover Photograph: EMILY GUDE PHOTOGRAPHY

Title Page Photograph: EMILY GUDE PHOTOGRAPHY

BLOOM Imprint
4810 Pt. Fosdick Drive NW, #127
Gig Harbor, WA 98335

ISBN: 978-1-7368481-1-1
Library of Congress Control Number: 2021948004

www.bloomimprint.com www.slowflowerssociety.com

Printed in the U.S.A.
by Consolidated Press, Seattle, WA

FOR EVAN

TABLE OF CONTENTS

INSPIRED GATHERINGS

DISCOVERING HOPE

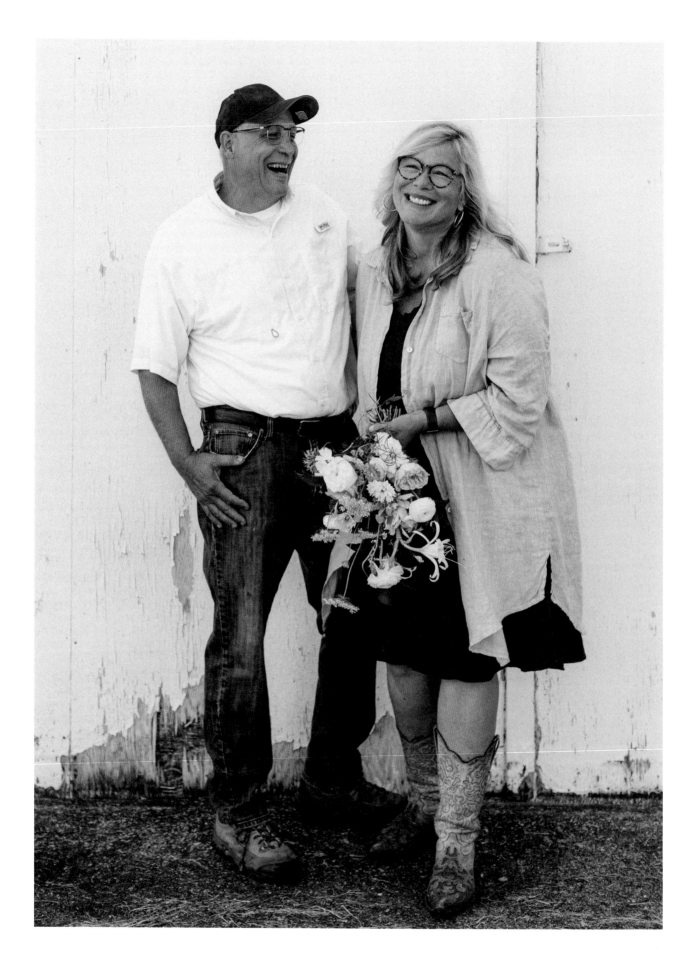

GRATITUDE

"EACH DESIGN I CREATE IS JOYFUL AND CATHARTIC,
AND EACH EXTRAORDINARY STEM I TOUCH IS IN HONOR OF
EVAN. HE IS THE DRIVING FORCE FOR SO MUCH
OF THE BEAUTY I CREATE."

As my remarkable life partner, Evan has given me everything I have: seven amazing kids, the opportunity to grow my career and to travel the world over, fields and fields of flowers, and a wonderful farm we named Hope.

To Evan, I know this flower life was not your dream, but you eventually supported every one of my ideas after your first resounding NO, something we both now recall with shared laughter. What many do not realize is how none of this would have happened without you. You took on parenting, bookkeeping, and farming to make my dreams become real. You built so much of this company literally with your own hands. You have also proven yourself to be one of the finest instructors to ever teach at our school.

To watch your mind work at lightspeed to find the fastest most affordable way to a solution or a design is a magnificent sight to behold. Not a soul I know is as capable as you. I know this without doubt every day when I see everything you have invested in our farm's soil and in its floral abundance. Hope will grow for many years to come.

EMILY GUDE PHOTOGRAPHY

FOREWORD
SUSAN McLEARY

Do you know Holly Chapple?

I'd been a florist for about six years when I started to hear this question everywhere. This question was always in response to my constant stream of curious, probing questions. I'd instantly fallen in love with floral design when a friend asked me to help with her wedding years earlier, but I stumbled around for some time while seeking out "my people" — fellow florists as passionate about the medium and hungry to learn as me. I had questions, frustrations, and most importantly — a feeling there was more to this practice than what was being demonstrated in the florist culture to which I was exposed.

Holly was recommended to me, as she had recently stepped into the role of mentor and leader in the world of event floristry.

She had created a community meant to educate and connect like-minded florists, The Chapel Designers. I can still remember the exhilaration I felt during my first Chapel Designers conference. It was truly a heady, transformative experience. Holly had fostered a culture of growth and possibility, attracting a group of incredibly talented, engaged, and passionate people who recognized this work has value and meaning. I could see immediately that these were "my people." This was a safe place to be vulnerable, and a safe place to share dreams. As an introvert who enjoys slow rumination, I see now that I purposely placed myself in Holly's orbit so I could borrow courage from her and gain the confidence to fully pursue my passion. Holly is a wonderful example of an "expander"— a person who has been where you've been and has achieved incredible things.

However, Holly goes beyond just showing us what is possible, she does everything in her power to help people make the connections necessary for growth. She is the ultimate connector, listening to people's needs and matching them with others who can help. She has helped me along my path in more ways that I can name. She's truly been a catalyst for my own career as a floral artist and educator. Holly's passion and influence have strengthened my resolve to make my work meaningful. She shows all of us that it's possible to weave together our relationships and experiences in an intentional life with flowers.

Based in Ann Arbor, Michigan, Susan McLeary is a floral artist, teacher, and author of "The Art of Wearable Flowers."

EMILY BERGER-CRAWFORD PHOTOGRAPHY

FOREWORD
GREGOR LERSCH

Holly Heider Chapple is incredibly adaptable and unafraid of change.

I liken her influence to a violinist with the most delicate touch of fingertips on the strings of an instrument. She draws from an unbelievable color sense that she expresses through her floral designs. Her aesthetic is a combination of spontaneous intuition, knowledge, and experience. She continually models new practices and opportunities for the members of Chapel Designers and for others in the floral profession. She is indeed an influential creative.

I first met Holly over the telephone — two floral educators and artists separated by the Atlantic Ocean. My native tongue is German, but we spoke in English. During our first conversation, I immediately sensed a person who knew what she wanted to accomplish. Holly communicated clearly, and in a succinct way, letting me know she wanted to talk about what she was setting about to do.

In contrast to the big floral industry conferences, she was at work creating something quite rare at Hope Flower Farm. Holly invited me to teach at Hope in 2015. During that visit to Leesburg, Virginia, I saw the farm as a work in progress and recognized its potential as both an important center for floral education and a successful event and wedding design studio.

Hope Farm is intimate and accessible, while also serving as a model for the floral profession. There, Holly and Evan have opened their doors to speakers like me, to top florists and horticulture professionals and to many others in the green field. She expresses the harmony that exists between growing flowers and floral artistry, thanks to this beautiful center she's created at Hope. As a teacher, she is generous with her knowledge, building trust and confidence in her students.

Holly's complexity is her greatest gift as it enables her to move comfortably between so many varied disciplines. She has a heart for this profession, for its designers, arrangers, and florists. She loves her peers and her students. She cares about their success. She models hard work, takes risks, and shares knowledge. She is much more than a great designer. She is a friend.

Gregor Lersch is a floral designer, teacher, and author of floral design books from Germany.

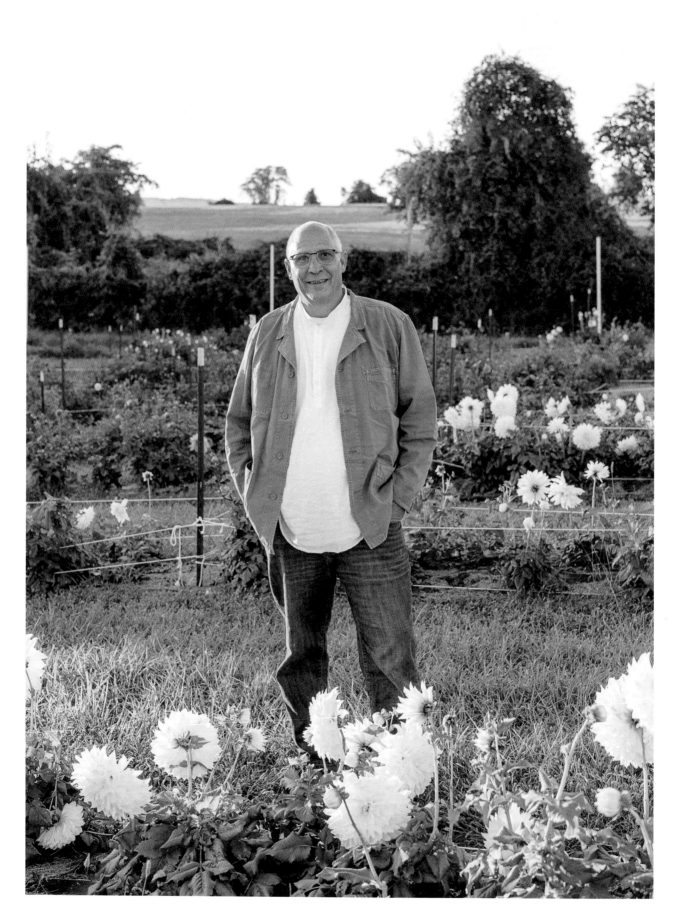

MARRIED2FLOWERS

This book is definitely Holly's story, but I was asked to share a bit from my vantage point. We have been together for nearly 35 years, and we've raised seven incredible children together, four sons and three daughters, and now we have Heider, our sweet granddaughter.

I met Holly via a friend who worked at her father's garden center. Things started out slowly, and then moved really fast.

Holly and I moved into our first home in 1987, a tiny white house we rented from her parents before buying it outright in 1992, encircled by five spruce trees, two blooming dogwoods, and a bunch of perennials. We didn't even look inside the house because the outside was so beautiful. Not long after that, a former school classmate of mine, a neighbor, asked Holly to design her wedding flowers. It was Holly's first wedding assignment. Things took off after that event.

> "HOLLY AND I ARE EXACT OPPOSITES AND I GUESS THIS HAS SERVED US WELL. WE'RE A BIT YIN-AND-YANG; CALLING US 'COMPLIMENTARY' PUTS A POSITIVE SPIN ON IT. I NEED HER TO SAY 'YES,' AND SHE NEEDS ME TO SAY 'NO'."

At some point, we decided to plow up the entire front yard and plant rows of stuff we'd never grow today, such as lilies. This was back in the late 1980s or early 1990s, and we started our own little front-yard flower farming venture. I think that's when the flowers started to take over. Up to this point, my sole memory of anything flower-related was planting gladiolas at my Dad's house when I was in my early teens. Fast-forward to my responsibilities growing flowers at Hope Flower Farm. That's when I remembered, "Oh, I've done this before." I would say I have some gardens that are well-tended, but I'm not a farmer.

Holly's floral design work gave us a second income and allowed Holly to stay home with our growing family. Flowers were in our house on Thursdays and Fridays. Everywhere! They were on the TV, on the kitchen table — every weekend it was flowers all over the house. On Saturday mornings, I would help load the vans, and then off Holly would go with her team to set up for a wedding. One thing I noticed for sure in those years was how she spent hours on the telephone, mostly on Friday nights, while also designing bouquets and centerpieces. I mean hours. She was encouraging and commiserating with other designers in the same boat as hers.

No matter how badly she herself feels, Holly gets her strength from helping others and building people up. This is how Chapel Designers was born!

RUDNEY NOVAES PHOTOGRAPHY

MARRIED2FLOWERS

By 2011, I quit my job in telecom and came onboard with Holly Heider Chapple Flowers. It was a welcome change. I had been in the same business for 20 years — and I was miserable. I had a great salary and a lot of seniority, but I just knew there was something more. I knew that the only way Holly Heider Chapple Flowers was going to grow was if I were to join forces with Holly and we focused on really big weddings. We dove in, and for a couple of years, I built all the lighting and drapes for our events. Later, I taught members of Chapel Designers how to design and build structures for their own installations.

Holly and I are exact opposites and I guess this has served us well. We're a bit yin-and-yang; calling us "complimentary" puts a positive spin on it. I need her to say "yes," and she needs me to say "no." My "no" just means, "I can't answer you right now. I need to go think about it for a while." I can go away and think about it for 15 minutes, or an hour, or a day. I can come back

> "AT SOME POINT, WE DECIDED TO PLOW UP THE ENTIRE FRONT YARD AND PLANT ROWS OF STUFF WE'D NEVER GROW TODAY, SUCH AS LILIES. ...AND WE STARTED OUR OWN LITTLE FRONT-YARD FLOWER FARMING VENTURE."

and tell you exactly how to do what you want to say "yes" to, and by then, I'll have formulated the whole plan. But in the moment, I'm going to say "no," and that's pretty much the way it is.

Somewhere in the middle, we always find the right path. This is what happened with Hope Flower Farm in 2015. The business and Chapel Designers were growing, and we needed a home base for the company.

We started looking for land again, which is when Holly's mother caught wind the asking price of Hope Farm had been significantly reduced. We had prayed a lot and we were searching for a sign. I'm pretty spiritual, so I considered the lower farm price my "burning bush." We called immediately and put a contract on the property. My favorite part about owning Hope Flower Farm is that I get to do something different every day.

Oh, and my Instagram account @marriedtoflowers? It's a nod to Holly and it means I'm married to a "flower lady" and to her life. I've come to flowers kicking and screaming, but I do love it. It has been a long, beautiful thing and we've both experienced some incredible relationships through this journey we've happily taken together.

Holly and Evan Chapple, with their family, photographed on the road to Hope Flower Farm, fall 2020.

RUDNEY NOVAES PHOTOGRAPHY

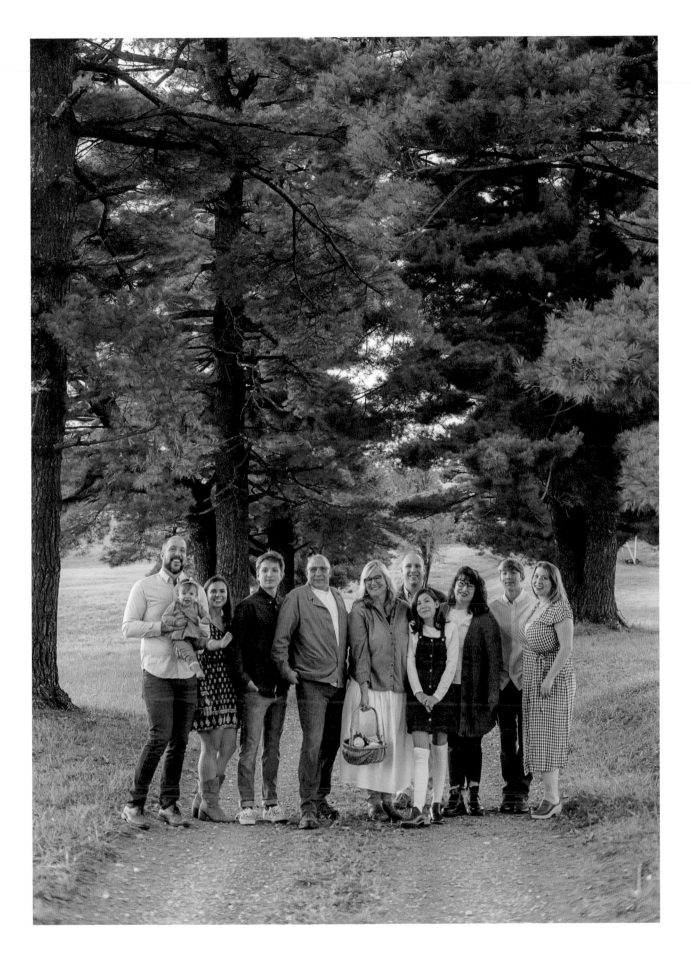

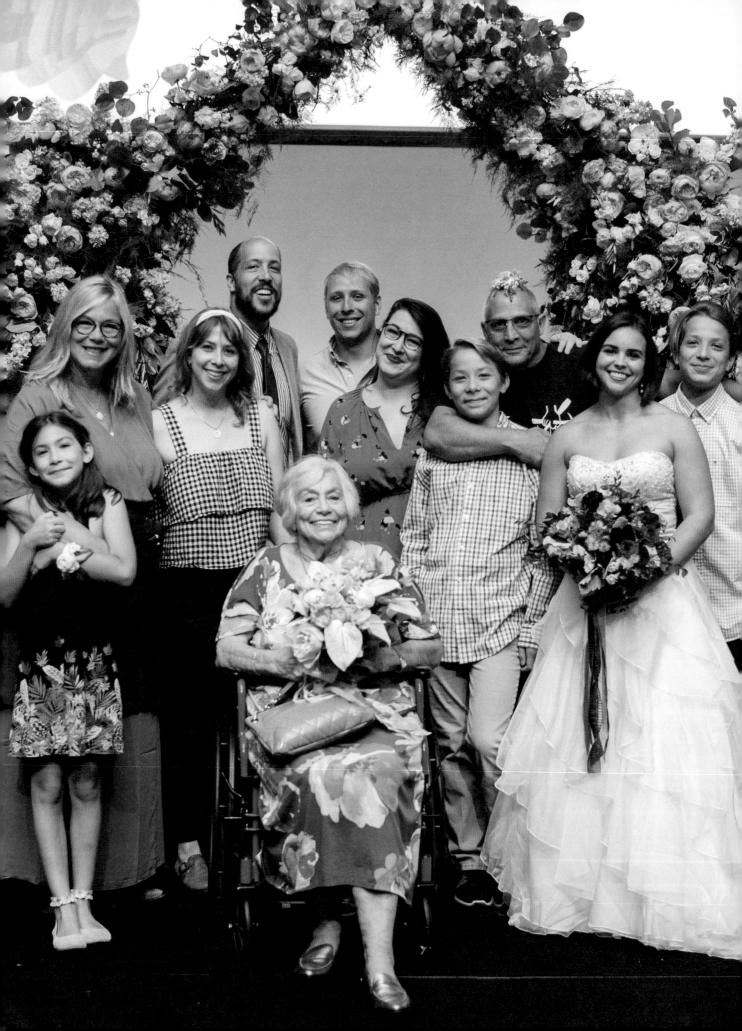

HOLLY'S JOURNEY

My floral journey is rooted in creativity, collaboration, and community. As you will see in this book, there was never a grand business plan to build my flower-centric life, but the constant affirmations I've received on this journey have guided my choices. Each experience feels connected by a strong thread of love, family, and friendship. I want to share it all with you: my heart, a life . . . in flowers.

I was born on Christmas Eve in 1965 and, fittingly, my parents named me Holly.

My farmer parents, Albert and Sheila Heider, raised five little girls (me and two sets of twin sisters) at Legacy, a 100-acre farm in Loudoun County, Virginia, a beautiful area northwest of Washington, D.C. They were both outstanding, incredible characters and our home was a 100-percent entrepreneurial environment. We sisters grew up in a world rich with a cast of unbelievable personalities, all craftspeople in their own right. There

was never anyone who didn't become family, coming and going through this house of chaos, thanks to my parents' open-door policy.

My earliest memories are of being in the garden beside my grandmother. Along with produce, my grandparents sold dahlias and other farm-fresh flowers for the Chillum Market in Chillum, Maryland. My father followed in their footsteps, first growing shrubs for his landscape design business, and then ultimately opening a retail garden center and produce stand. As children, we had to water plants every day, as well as help sell produce. Think of it: He parked a truck at the end of our driveway; traffic whizzing by would see five little girls sitting on the truck, selling corn and tomatoes. It probably looked desperate, but we sold a lot of corn. Without question, Daddy was a terrific marketer!

I spent my childhood in and around edible and ornamental plants at the family business,

This family portrait was taken on the main stage at the 2018 American Institute of Floral Designers Symposium, one of Holly's most significant speaking engagements to date.

LUCK LOVE PHOTOGRAPHY

Heider's Nursery. It was where we five sisters were exposed to a constant education about gardening and farming, although at the time we weren't aware of its value. We also had cattle, horses, and countless other creatures. As children, we would race our ponies through the fields, jumping Daddy's rows of shrubbery. I still remember the rush of excitement I felt jumping over his bushes. Looking back now, we all realize it was where we learned the key life-enriching tools we would take into our businesses.

Chrysanthemums pervade my first flower-growing memories. As children, my younger sisters and I were enlisted to help in the fields to grow mums. Our tasks included filling all the pots with soil and planting the plugs. We trimmed back the plants to shape them until they grew more substantial in size, and then we rolled the buds to postpone blooming until fall.

Daddy would walk through the fields and say, "Mum's the word, girls. Mum's the word." I remember just wanting to throttle him, but also getting a big kick out of his clever sense of humor. I was so fortunate as a youngster to see the benefit of helping in my family's business.

It was during Christmas time at the nursery when I learned how to design. We never really sold arrangements any other time of the year, but at Christmas we needed to make wreaths, garlands, centerpieces, and kissing balls. They were definitely projects worth learning. No surprise, but all of these skills have come in pretty darned handy in my life as a floral designer.

Adding to the nursery's holiday spirit, Daddy built a tradition and an experience for the families in our community who came to our nursery to buy their Christmas trees. He had a team of mules and a wagon, and he decorated the wagon with bells; the mules wore hats. On every weekend before Christmas, families and friends arrived and could take wagon rides. There was hot malt cider to drink and a candy-cane tree. Looking back, it was an amazing learning experience for me. For our first holiday open house at Hope Flower Farm, of course, I had a team of horses and a wagon ready. I knew what to do and how to put a little extra into creating festive experiences for our guests.

My Mom was also an inspiration. One of the major principles of my company comes from her telling me to "Stay at the dance with the person who brought you." This has served me well. It has kept me continuing to arrange flowers for the past 28 years for my first restaurant client. Even when I was designing for luxury weddings, I never walked out on this restaurant, even though it was a modest delivery every single week. My loyalties and my relationships and the way I stick with people represent my company's core values.

Evan and I married young and started our family immediately. We rented a little house from my parents, where the garden was filled with spirea, viburnum, every kind of hydrangea, old-fashioned roses, blue spruces, and lots of perennial flowers. I started planting more flowers and tending to the garden, as our house was quite humble and I wanted to decorate and make things lovely. Of course, I had a massive resource because my father had a garden center and he kept giving me more plants.

My first paying job as a florist occurred in the early 1990s. My parents had a contract with the Washington International Horse Show to decorate the stadium. I was 22 years old and the show needed a florist. My Daddy said,

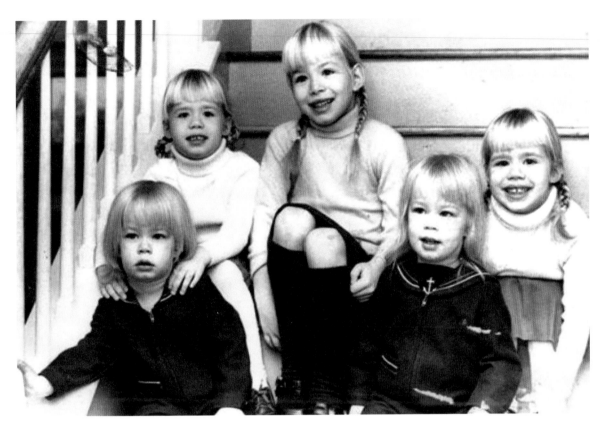

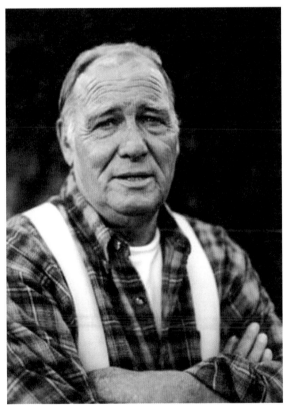

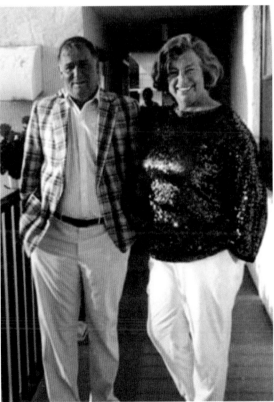

TOP: Holly (center) surrounded by her two sets of twin sisters. BOTTOM LEFT: Albert Henry Heider had a landscaping and lawn maintenance company prior to starting his nursery. BOTTOM RIGHT: Albert with Sheila Graham Heider.

HOLLY'S JOURNEY

"ONE OF THE BEST THINGS ABOUT MY LIFE IS HAVING DAILY MOMENTS OF GRATITUDE OVER THE BEAUTY WE ARE GROWING OR EXPERIENCING. THESE THANKFUL BURSTS HAPPEN BECAUSE EVERYTHING I DO, WEAR, THINK ABOUT, AND DREAM OF, IS SOMEHOW DEEPLY CONNECTED TO MY LIFE EXPERIENCES WITH PEOPLE AND FLOWERS."

"Oh, my daughter can do it." Mind you, I'd only done the Christmas arrangements for him at this point, but I got the contract!

My first professional arrangements had to be created in Crown Royal liquor boxes and tins because the company was a sponsor of the horse show. The designs were also red, white, and blue to incorporate the signature colors of Crown Royal — a true challenge. I made massive arrangements for the ends of the jumps, as well as dozens of rose presentation bouquets, including a huge bouquet just in case the First Lady might arrive. Happily, I kept this design contract for many years.

A fundamental part of my story began around the same time. Daddy was a vendor at our local Leesburg Flower and Garden Show. He exhibited there, selling bedding plants, which meant I brought buckets of lilacs and whatever else I could gather in the garden or from the wild, making and selling them as organic bouquets at his booth. At this show, people started asking me if I designed for weddings. Inquiries poured in and, in retrospect, I see how my family "incubated" my floral design enterprise. My sisters and all of their friends were of marrying age and needed flowers.

Daddy kept referring his customers to me, not really differentiating between his garden center and my floral work. It never crossed his mind I didn't know how to design something, which explains another motto in our family: "Figure it out. Learn how to do it."

My business has always had only my name: Holly Heider Chapple Flowers, because in the early days, people said, "Get Holly Heider to do your flowers." This business evolved by gathering blooms from my own property, or by going to Daddy's garden center to buy even more perennials to add into my designs.

I used to say I am "self-taught" as a florist, but the truth of the matter is that I learned my floristry skills thanks to my father. I also learned how to work hard and how to make a living from what I create. To this day, I cherish my mother's reminder: "These are your hands. They're tools. Use them." And so, from her advice, I believed I had everything I needed: a sense I could get myself out of any situation by working hard and by being creative.

Albert Henry Heider worked the fields with a team of mules and helped his parents sell produce at the market and later he returned to driving teams of mules and work horses at state fairs and even judging at competitions. Sheila Graham Heider was a skilled horsewoman and entrepreneur, who raised five little girls while helping to manage the family's nursery business.

PHOTOGRAPHS FROM THE HEIDER FAMILY ARCHIVES

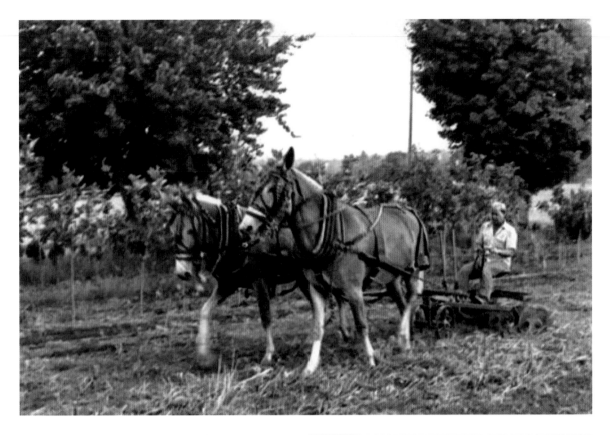

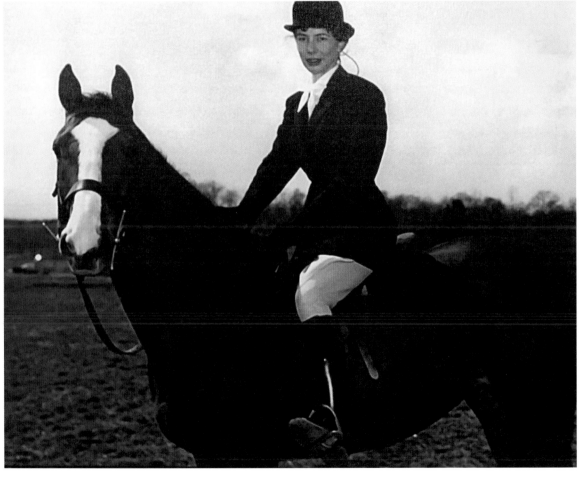

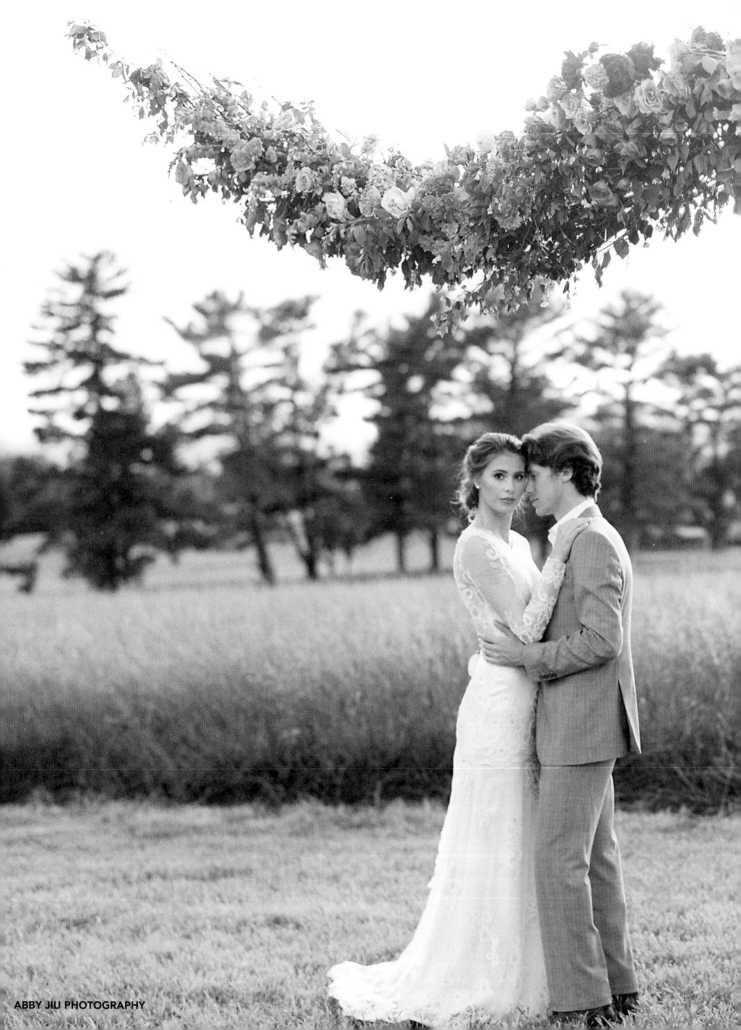

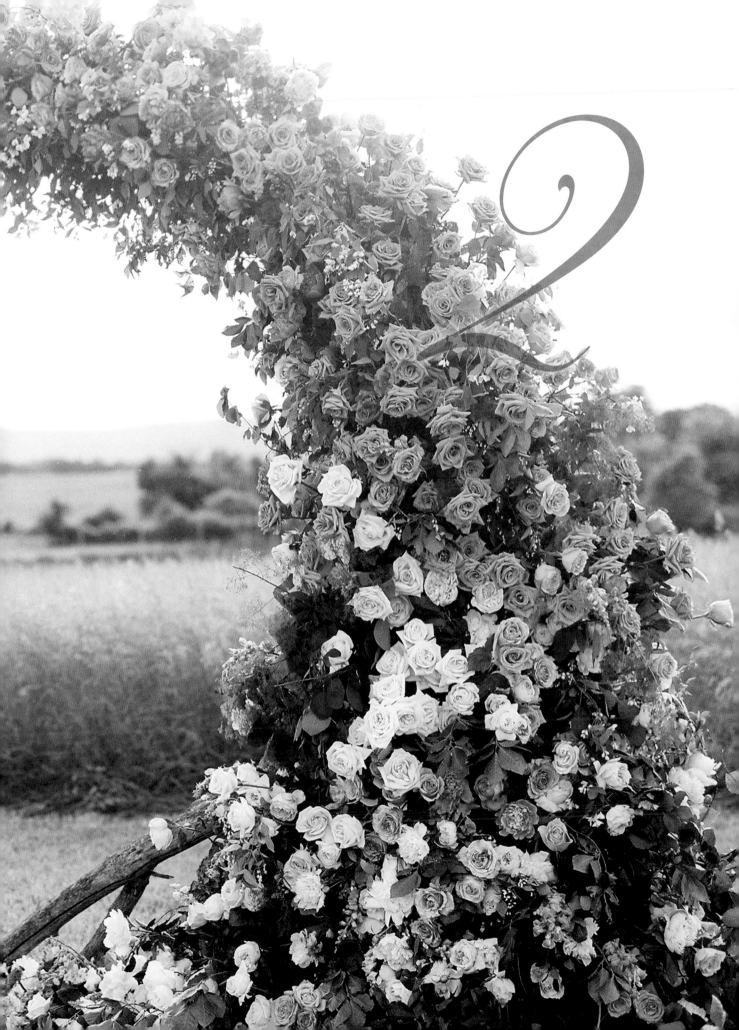

A CREATIVE PRACTICE

In the garden or the studio, I find myself asking, "What flowers get to come to the party?" as if they are invited guests. My notion that flowers are like people with distinct personalities helps me to choose which blooms will be added into the designs. I look at their shape, form, and color, and this tells me which blossoms will add to the conversation or the overall feeling of the event. To complete the harvest or the designing, I look for "sisters" or "brothers," stems to connect the design and make the transition comfortable.

As a result, my creative work is multifaceted. For example, for a wedding I will start by considering a couple's preferred colors, going through my mental floral database, thinking about which flowers of the season I should be bringing to their wedding. I propose color combinations, shades within the palettes, flower forms and textures, all to make the design more enticing with layers, shapes, and tones.

The heart of my design practice begins close to home. It is a rare occasion when I don't pull a botanical element from my garden. Regardless of the time of year, I will make a trek around the property, either at my house or at the farm. I'm looking for that one special element that will make a design "Hollyish." Whatever this ingredient may be — a clematis vine, a sprig of an herb, a cluster of berries — it takes my designs to the next level and it's my creative gift to the recipient.

"The answer's always in the garden," has become my mantra.

When past clients and readers of my blog started using the term "Hollyish," I was surprised and moved. I think "Hollyish" is their shorthand to describe the fact that everything I create, no matter the style, is well executed. "Hollyish" bouquets are always full and lush. I pay incredible attention to the quality and the ingredients.

PRIOR PAGES: This foam-free floral arc is from a concept Holly sketched and created with attendees at the May 2019 Chapel Designers Conference. LEFT: Teaching at Florabundance Design Days in Santa Barbara.

MINETTE HAND PHOTOGRAPHY

A CREATIVE PRACTICE

"THE FLOWERS LEAD ME. I BUILD MY DESIGNS AROUND
A SHINING STEM, AN EXTRAORDINARY BLOOM
OR TYPE OF FOLIAGE. I WANT TO ADD LAYERS AND LEVELS
OF COLOR, TEXTURE, AND OTHER BOTANICAL ELEMENTS
TO ENHANCE MY KEY FLORAL CHOICE."

The little elements are not overlooked.

Everything I choose has a story. It might be special because I planted it in honor of my mother, or because someone I admire gave me the seeds, or because I love the blossom's color and texture. When I'm given creative freedom at the farm for a photo shoot or an editorial project, I take that walk and see "who" is singing to me. The flowers lead me. I build my design around a shining star, an extraordinary bloom or type of foliage. I want to add layers and levels of color, texture, and other botanical elements to enhance my key floral choice.

As a foundation, I believe each flower has a purpose in the composition of a bouquet or arrangement. There is a base layer, which is often foliage, hydrangeas, or carnations that form a botanical mass. Then, I select the line flowers, such as stock, snapdragon, or delphinium. Focal flowers, like dahlias, roses, or peonies, create the next layer.

Supporting flowers come next, and these are items such as spray roses or scabiosa. Finally, I add elements of wispiness to give the design movement and add another level of texture. But I can't stop there. I'm always adding botanical accents and stems to give a final layer of dance.

All things considered, to me, my creative practice is a form of relaxation, even though others may consider it work. When I'm doing what really pleases me, I hear a voice in my head saying, "Let it be loose and airy. Add depth. Add texture." As a bouquet comes together, as I look at each blossom, branch, or leaf, I experience moments of pure satisfaction, and these I often vocalize both internally and out loud. Call it pure pleasure or celebration!

These Food + Flowers seasonal vignettes were created in collaboration with Chris and Carlene Thomas over a multiyear period to showcase the edible flowers and food in Virginia. Chris and Carlene used the same edible elements in a variety of recipes for cocktails and food. The complete recipes can be found on CarleneThomas.com.

FOOD + PHOTOGRAPHY BY CHRIS + CARLENE THOMAS

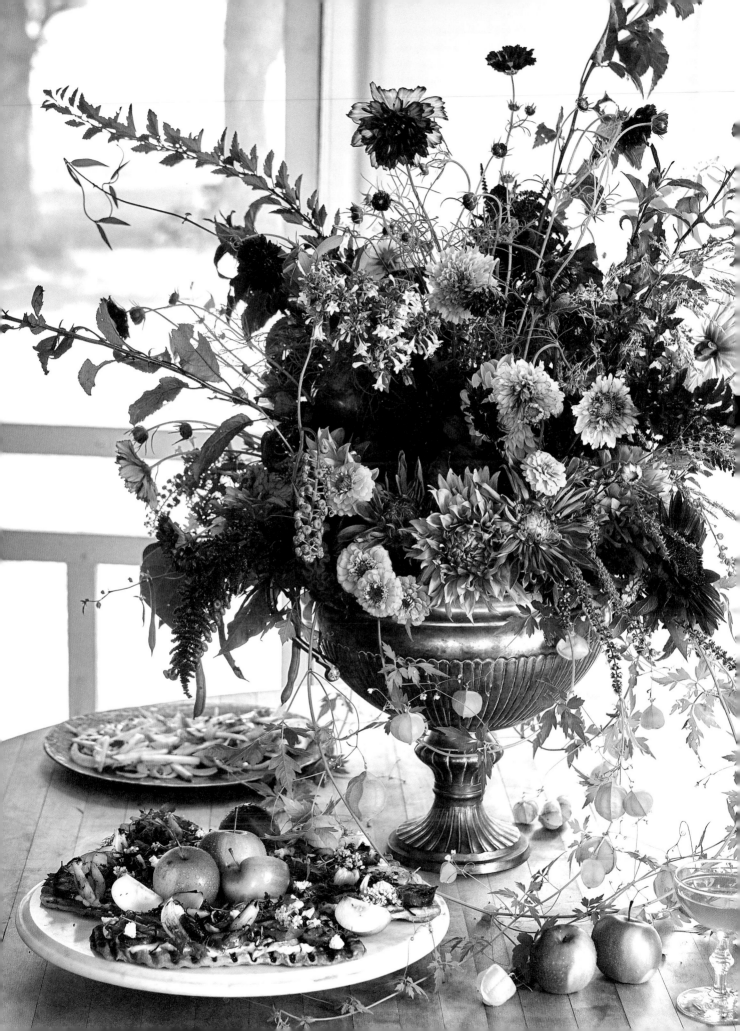

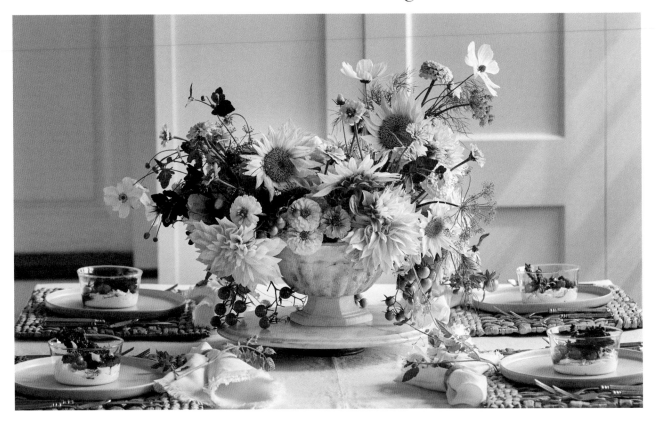

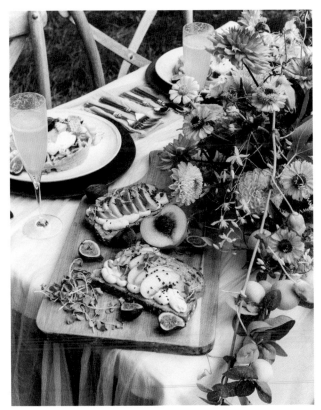

These Food + Flowers vignettes created with Chris and Carleen Thomas use the blooms harvested at Hope Flower farm in late Summer and Fall to showcase the edible flowers and food in Virginia. Chris and Carlene used the same edible elements in a variety of recipes for cocktails and food. The complete recipes can be found on CarleneThomas.com.

FOOD + PHOTOGRAPHY BY CHRIS + CARLENE THOMAS

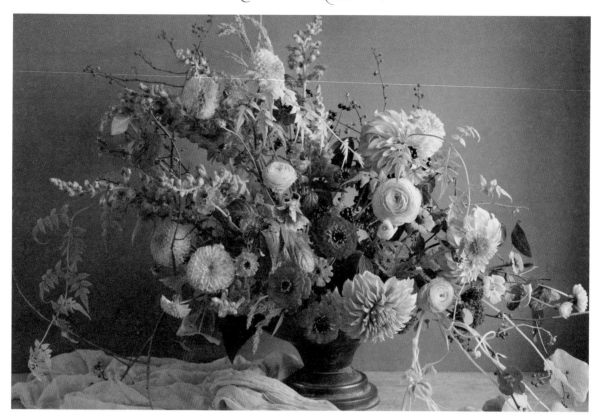

Created just before frost, this bouquet features the very last blooms of the season, with three dahlia varieties, zinnias, nasturtiums, jasmine vine, snapdragons, celosias, bittersweet, straw flowers, and viburnum foliage, plus ranunculus.

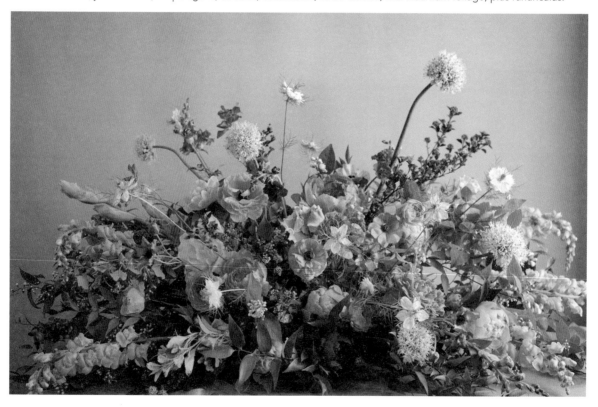

Designed for a rectangular table, this arrangement of primarily Hope Flower Farm-grown blooms, includes alliums, ranunculus, nigellas, snapdragons, irises, nandina berries, and foliage.

PHOTOGRAPHY BY HOLLY HEIDER CHAPPLE

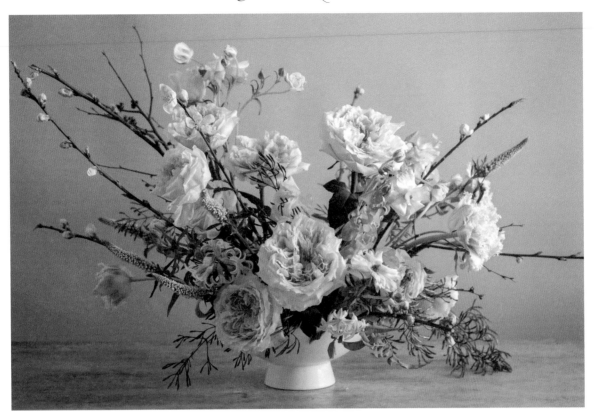

The design features peach branches from Hope Flower Farm's orchard, including jasmine vines, hyacinths, veronicas, sweet peas, and a special Alexandra Farms pink rose.

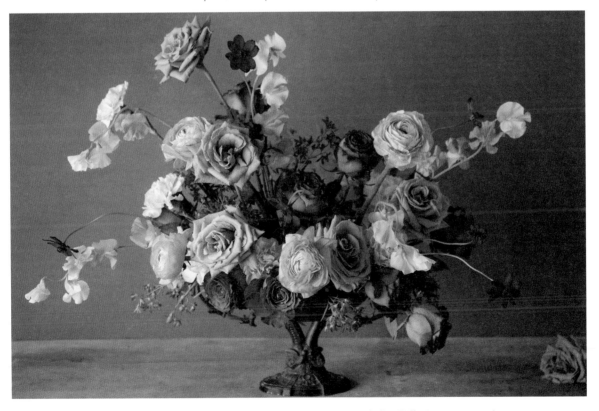

For this celebration of roses, Holly filled her favorite vintage compote with the 'Toffee' rose, ranunculus, sweet peas, the 'Precious Moment' garden rose, and cosmos.

PHOTOGRAPHY BY HOLLY HEIDER CHAPPLE

ARRANGEMENTS

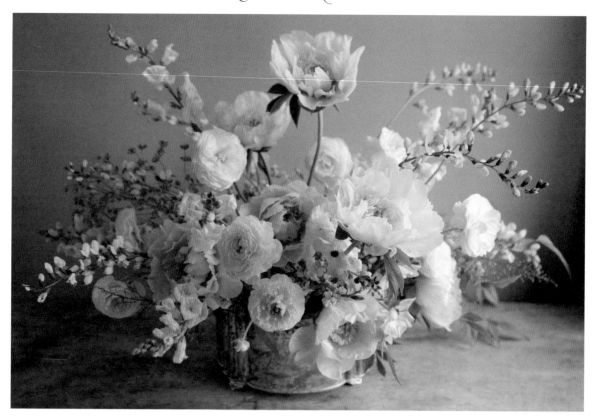

This gorgeous display of Hope Flower Farm-grown blooms, including includes 'Lemon Chiffon' peonies, ranunculus, butterfly ranunculus, snapdragons, nandinas, and baptisias.

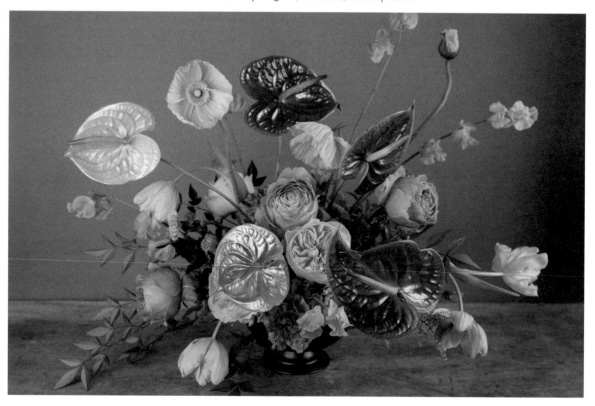

In this ethereal arrangement, iridescent anthuriums from Haus of Stems, are paired with 'Juliet' roses, tulips, sweet peas, carnations, poppies, and 'Rosa Loves Me' garden roses.

PHOTOGRAPHY BY HOLLY HEIDER CHAPPLE

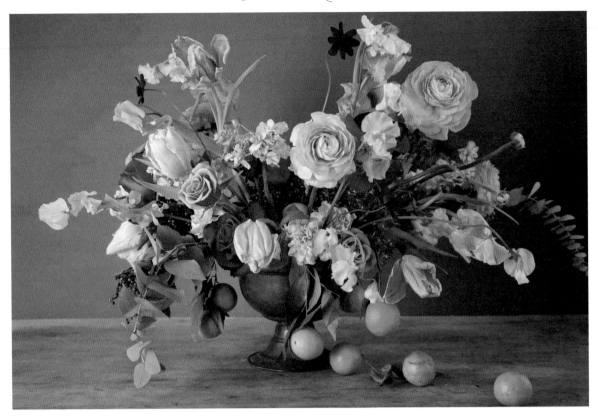

This gift of December 24th birthday flowers from daughter Abby to Holly, transforms a delightful arrangement of ranunculus, tulips, sweet peas, roses, cosmos and citrus accents into an early glimpse of spring beauty.

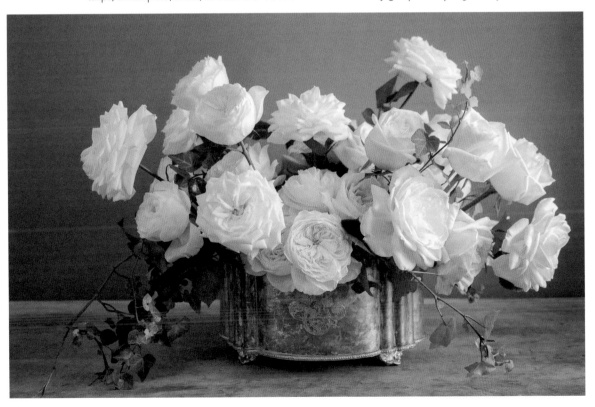

An arrangement created for a "Living Life with Flowers" virtual floral design class features Alexandra Farms garden roses, including the 'Alabaster' and 'White Cloud' varieties.

PHOTOGRAPHY BY HOLLY HEIDER CHAPPLE

INNOVATIONS

"CURIOSITY AND EXPERIMENTATION ARE A HALLMARK OF MY CREATIVE PRACTICE AND I KEEP REACHING FOR NEW SOLUTIONS, TECHNIQUES, AND TOOLS TO ENHANCE MY AESTHETIC STYLE."

In November 2014, confidence in my ability to problem-solve any creative challenge was put to the test while designing the wedding flowers for my client and friend Kelly Lanza. This bride had a very specific request for me and even after 22 years of designing, I was unsure how to execute her wishes. She asked for an open, horizontal bouquet with "signature star blooms." Definitely a puzzle to achieve.

After a few hours of contemplation, I devised a plan. In order to achieve the style, I needed a device that would hold stems in an open shape. I constructed an "egg" form out of chicken wire and my new mechanic was born. The contraption allowed me to open up my bouquet and make everything loose and airy, so each stem could shine as an individual element. I can't even begin to explain what this moment felt like, but everyone there knew something magical had just happened.

In April 2015, we traveled to the London Chapel Designers Conference, where we created and photographed a tablescape with centerpieces. We were using borrowed vessels, which meant I didn't want them to be taped or have foam packed inside them. I also didn't want to shove chicken wire inside for fear of scratching the finish.

For a solution, I said to the group, "What if we make a bigger egg form that can rest on top of the vessel?" It was larger than the rim of the vases we were using, so right there in London, we started calling the form a "pillow." Almost astonishingly, another innovation emerged. I also tried the method with a tall, elevated vase, my first foam-free elevated arrangement. Once again, I knew something magical was happening and we were witnessing a change in the industry. Many leading floral educators called my egg and the pillow mechanics "game changers," and Syndicate Sales took notice. Three years after making my first egg prototype for Kelly's wedding bouquet, at Flowerstock 2017, we unveiled the first egg and pillow samples for my new product line called Holly Heider Chapple x Syndicate Sales.

Since then, I've collaborated with Syndicate Sales to develop many more mechanics for foam-free floral design, as well as a full line of glass, plastic, resin, and ceramic vessels created especially for wedding and event florals. And this all began simply because I had to figure out a solution to a design puzzle.

Innovation takes many forms, and I believe for a few fleeting moments, God or the Universe gave me a marvelous valuable and worthwhile idea.

In partnership with Syndicate Sales, Holly's product developments are being manufactured as accessories, mechanics, and vessels to the floral marketplace.

REBEKAH MURRAY PHOTOGRAPHY

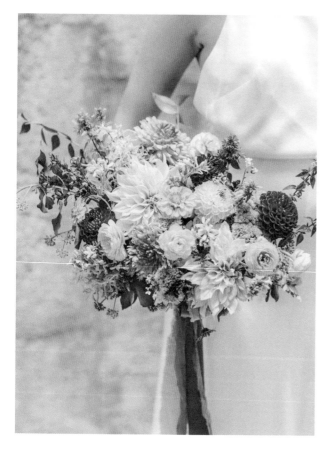

CORAL ORCHIDS

TOP: A romantic cascading bouquet in a breathtaking palette features 'Coral Charm' peonies with 'Golden Treasure' orchids, blue delphinium, and touches of blue muscari.

DAHLIAS · ZINNIAS

BOTTOM: Holly demonstrated the design for this bridal bouquet during a Chapel Designers Workshop. It features dinner-plate-sized 'Cafe au Lait' dahlias, zinnias, and ornamental grasses grown at Hope Flower Farm.

TOUCHES OF PLUM

TOP AT LEFT: Embodying the best of fall and featuring favorite muddy red shades, the bouquet contains touches of plum, peach, and coral-toned botanicals, including dahlias grown by Hope Flower Farm.

PASTEL POPPIES

TOP AT RIGHT: Pastel poppies, peonies, and deutzia sprigs, and locally grown sweet peas are gathered into a joyous bridal bouquet in an unexpected palette.

WHITE · BLUSH

BOTTOM AT LEFT: A classic bouquet gets the romantic treatment, with cream, white, and blush peonies in full bloom. Sweet peas and garden roses lend textural details.

CASCADING CORALS

BOTTOM AT RIGHT: The design for a September wedding with Hope Flower Farm includes dahlias and nandina berries and foliage. Like many of Holly's floral commissions, this bouquet is carried horizontally, but with a slight twist, the design will appear as a cascading bouquet.

TOP: KATE HEADLEY WEDDINGS; BOTTOM: VICTORIA HEER PHOTOGRAPHY

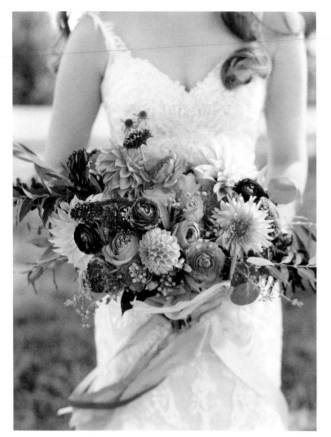
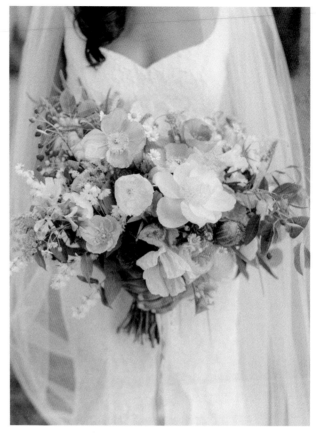
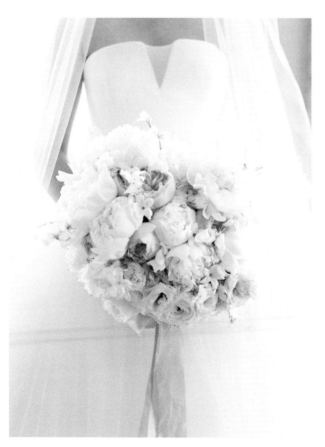
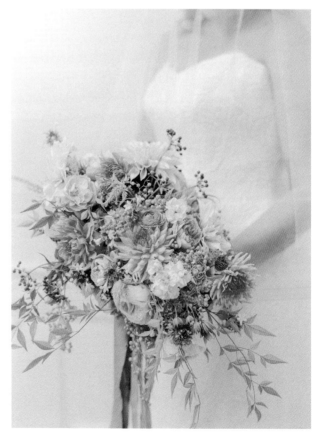

TOP LEFT: KATE HEADLEY WEDDINGS; BOTTOM LEFT: ABBY JIU PHOTOGRAPHY;
TOP RIGHT + BOTTOM RIGHT: JODI + KURT PHOTOGRAPHY

CREATIVE COMMUNITY

"As CHAPEL DESIGNERS TOOK SHAPE AS AN ORGANIZATION AND, BUILDING CONFIDENCE, OUR MEMBERS STARTED TO LEAD THE INDUSTRY. TOGETHER, OVER THE NEXT FEW YEARS, WE ESTABLISHED SOME OF THE PROFESSION'S BEST PRACTICES."

In the early days of social media, I discovered Twitter as a place to connect with other florists. Social media as a communications channel was so insignificant then. You had the sense you were only talking to the people who you followed. As I built a rapport with other florists, I began to acquire a reputation as a go-to person, someone willing to share her knowledge when it was hard for studio florists to find information. In 2010, when I was eight months pregnant with our seventh child, I started writing my blog, "The Full Bouquet," which you can still read online. Because of this and my use of Twitter, I became visible to a growing online community, building my role as an educator, even though at the time I didn't see myself in this position.

In 2010, I met the well-known event designer David Beahm at the Wedding 360 Conference in San Francisco. Naturally, we quickly became friends and David generously said he would show me around New York if I ever came to visit. Not long afterwards, Elodie Perrier, another floral designer, traveled from her home in France to intern with me. To thank her for spending her time, I hosted her for a New York trip, and then connected again with David. I would have never bothered David for myself, but I really wanted Elodie to have this experience. David took us to the flower market, to his studio, to his penthouse — we had an amazing time. Our relationship and the rapport between us deepened.

In 2010, I posed this question on Twitter: "Who wants to meet me in New York City?" It was just a casual comment, really, but the response was incredible. People I didn't know started to respond saying, "Yes, they planned on meeting me in New York." I was flabbergasted and thought, "This idea is really turning into a workshop or a conference."

That's when I realized a call to David was imperative, to ask if he would help me pull off a workshop. At the time, I also realized this gathering needed a name; it's going to be something. Which is how Chapel Designers was born — the first collective of wedding florists and event designers.

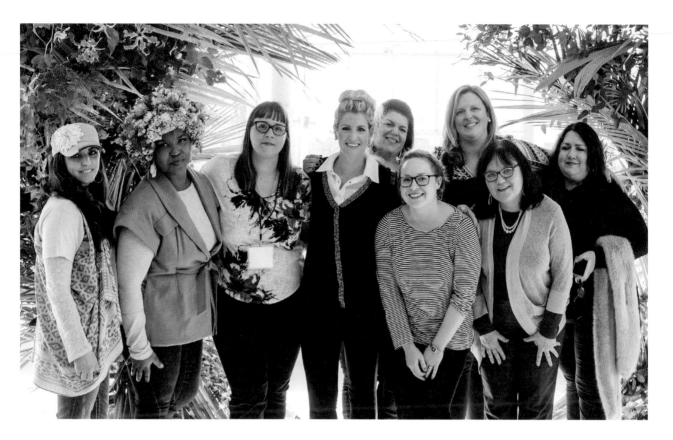

At the 2016 NYC Chapel Designers Conference, friends new and old gather. TOP FROM LEFT: Torey Clark Dunham, Isha Foss, Tina Sharpe, Mary Coombs, Dawn Clark, Michelle Edgemont, Alicia Magnier, Laura Iarocchi and Courtenay Lambert.
BOTTOM FROM LEFT: Kasia Hats, Holly Chapple, Susan McLeary and Hitomi Gilliam.

AMANDA DUMOUCHELLE PHOTOGRAPHY

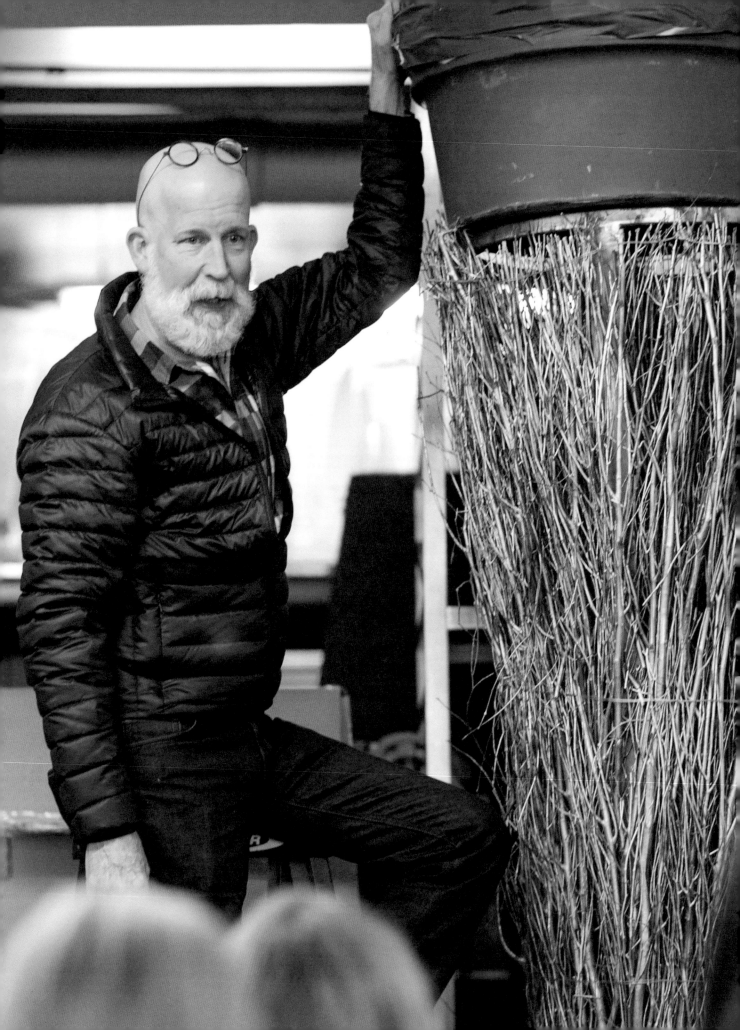

CREATIVE COMMUNITY

"I AM ONE HUNDRED PERCENT COMMITTED TO DRAWING DESIGN ELEMENTS FROM CUTTING GARDENS AND FLOWER FIELDS. I KNOW I WILL BE UNDERWHELMED IF WE DRIFT AWAY FROM THIS CORE VALUE OF EVERYTHING INHERENT IN SLOW FLOWERS DESIGN."

Fourteen of us gathered in New York City that first year. At our first meeting, as a group, one-by-one we each truthfully described who we were and what we did. No one had really ever done this before: bringing together wedding and event floral designers in the same field to talk about problems, processes, and ways to grow our businesses. It was a massive meeting of the minds.

As Chapel Designers took shape as an organization and, building confidence, our members started to lead the industry. Together, over the next few years, we established some of the profession's best practices. Chapel Designers grew to 32 members, and then to 70. Soon we started expanding our workshops, holding them in other cities and countries.

As an organization, Chapel Designers has grown into a global support system for weddings and special events floral designers. Our goal is to provide a supportive and nurturing environment that encourages and cultivates the unique and individual talents of designers in this group. We've forged strong industry relationships and our close friendships with one another — and that is the magic of Chapel Designers.

After more than 28 years in the floral and events industry, I recognize the challenges facing floral designers. This collective group fosters an environment dedicated to success in each designer. We encourage members to maintain their own identities, design from their hearts, and learn to listen and trust their intuitive voices. Support of individuality serves as a catalyst for new trends and creative designs in the floral industry.

From this beginning a decade-plus ago, flowers have truly become my passport to the world. Countless opportunities to teach floral design have opened for me and expanded my love for community and education. I've taught for Chapel Designers and other groups in England, Scotland, Canada, Russia, China, South America, and Australia. I've taught numerous times at Florabundance Design Days in Santa Barbara, California, and on the main stage for the American Institute of Floral Designers. Sometimes I laugh when I hear myself teaching or telling my stories, when I hear what flies out of my mouth. I think, "Wow, I actually know a lot, and this has been a miraculous ride!"

David Beahm presenting at the 2015 NYC Chapel Designers Conference. David was the first educational contributor for Chapel Designers and continues to teach each time Holly brings a conference to New York.

JODI + KURT PHOTOGRAPHY

CHAPEL DESIGNERS: NYC

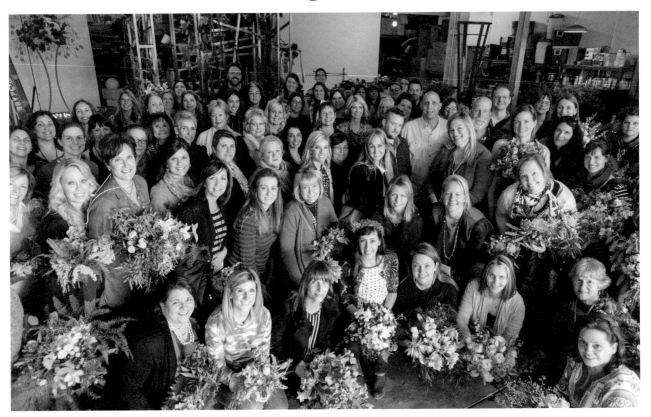

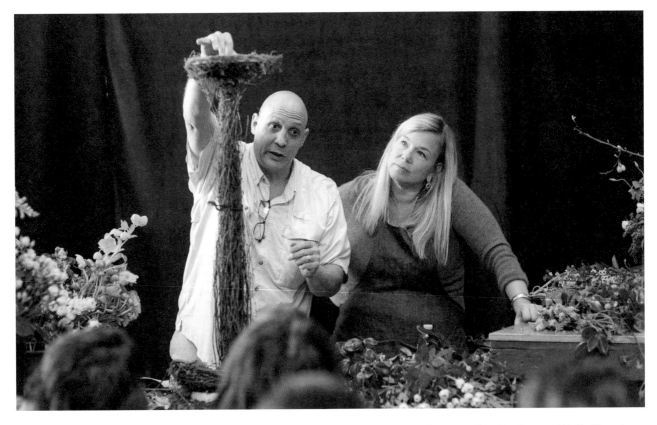

TOP: Attendees with their floral arrangements at the 2014 NYC Chapel Designers Conference. BOTTOM: Evan and Holly Chapple collaborating on a presentation about the mechanics of elevated floral pieces. AT RIGHT: Floral artist and educator Françoise Weeks, one of Chapel Designers' original instructors who remains an incredible source of inspiration for the creative community.

JODI + KURT PHOTOGRAPHY

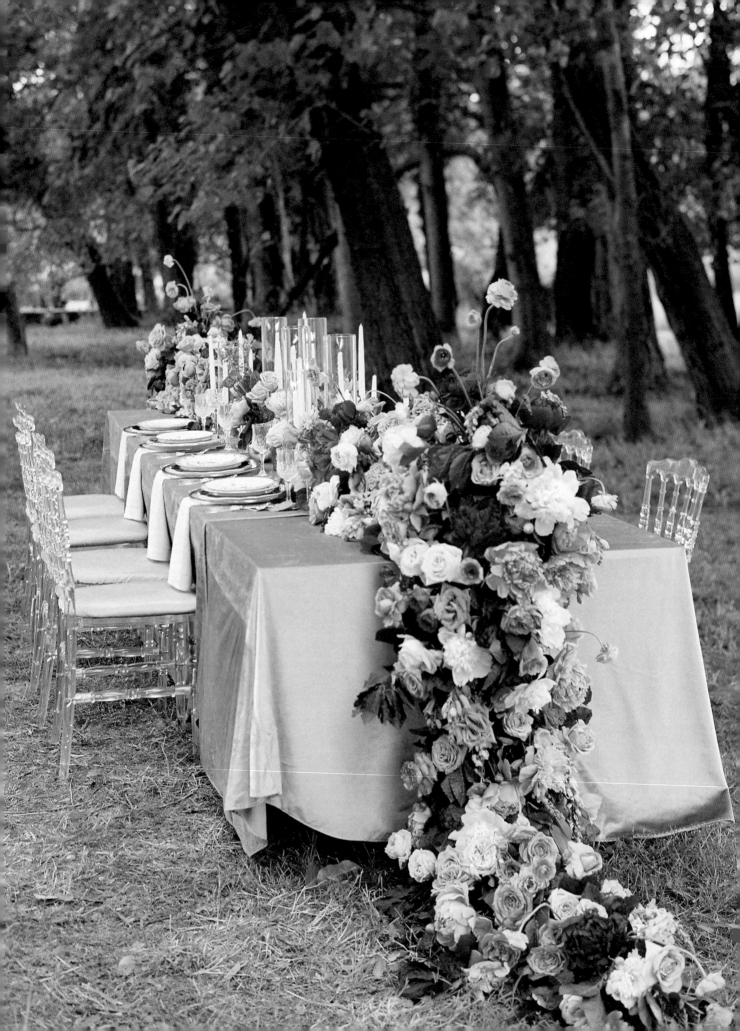

CHAPEL DESIGNERS

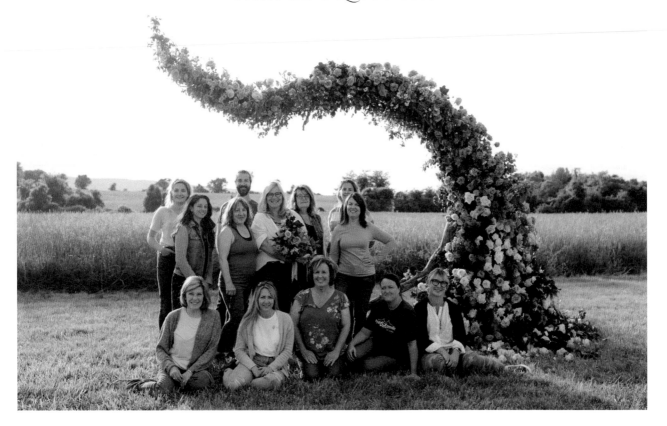

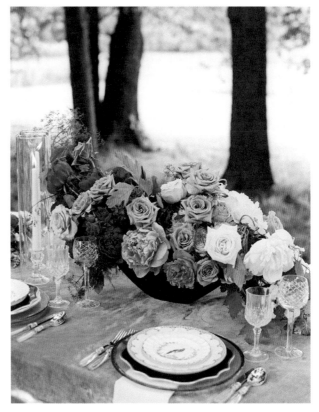

A peony tablescape created by attendees at the 2019 Chapel Designers Conference at Hope Flower Farm, with instruction from stylist Shira Savada. Students worked with Holly and Evan to produce a large-scale, foam-free, sustainable floral arc. Other instructors included Django Voris of Big Lush and Cheri Garner of Southern Stems Co. A fanciful cake created by Buttercream Bake Shop.

ABBU JIU PHOTOGRAPHY

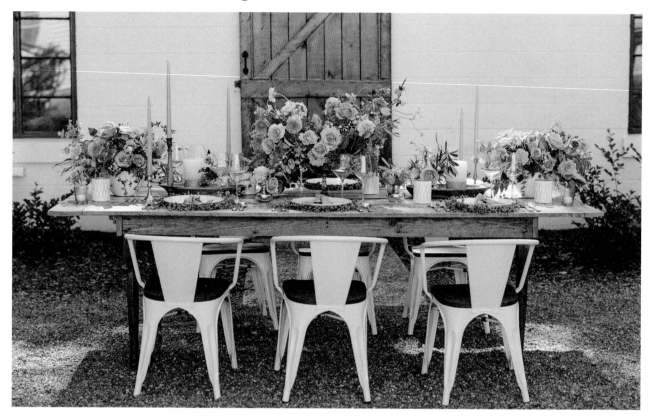

Attendees of the 2017 Chapel Designers North Carolina Conference collaborated on a styled shoot at The Parlour at Manns in Chapel Hill. The palette featured smoky mauve and golden roses and included flowering oregano and abelia. Students learned to create cascading bouquets, floral tablescapes, ceremony installations, and styling techniques.

SARAH COLLIER PHOTOGRAPHY

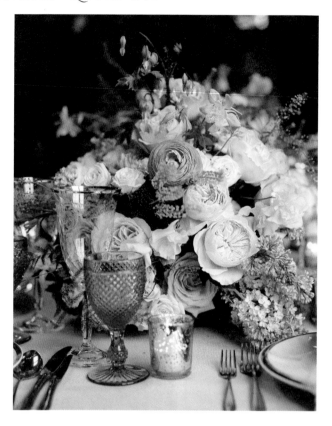
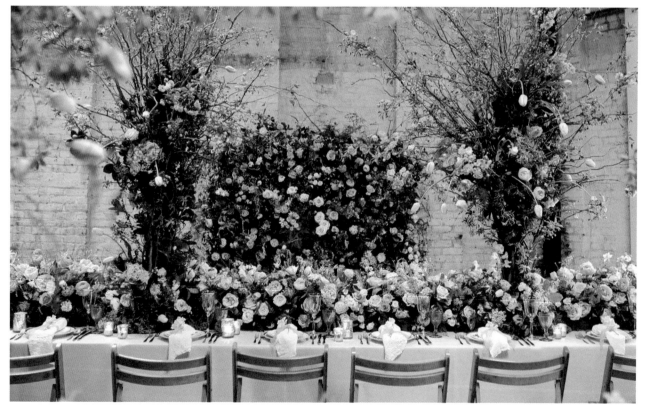

Instigated and facilitated by Chapel Designer Nick Priestly of Mood Flowers, Chapel Designer Conferences have expanded to European cities, including London in 2017. Attendees took over a warehouse venue and created large-scale installations, tablescapes, and centerpieces that highlighted seasonal flowering cherry branches, roses, and peonies. Holly created her first pillow-style mechanic here.

DASHA CAFFREY PHOTOGRAPHY

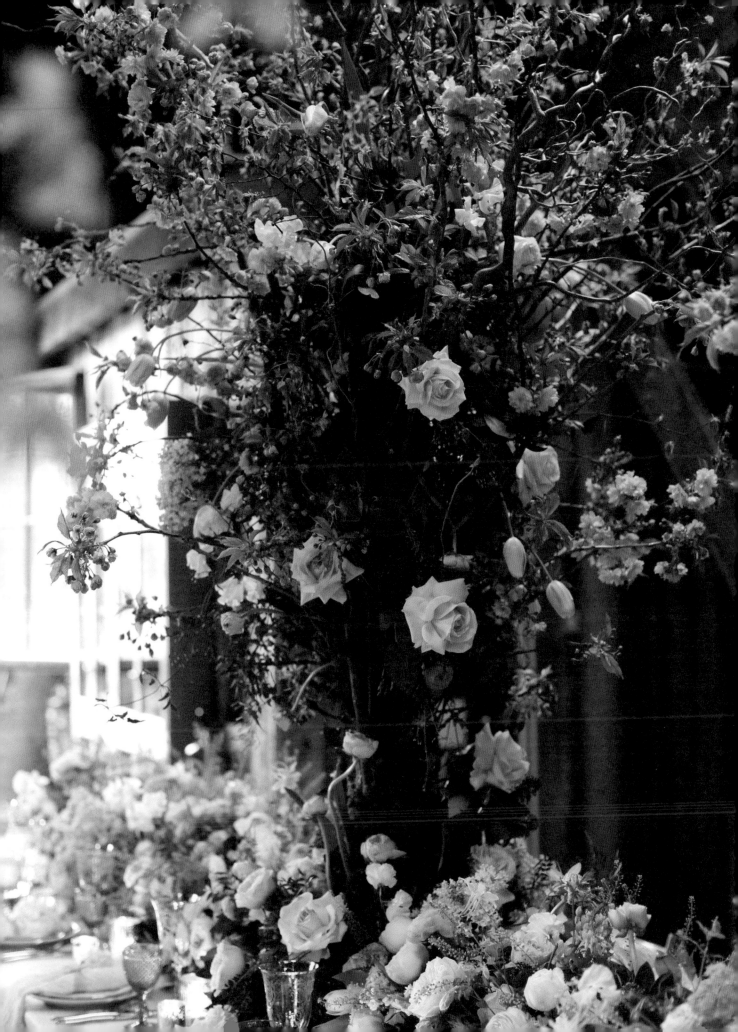

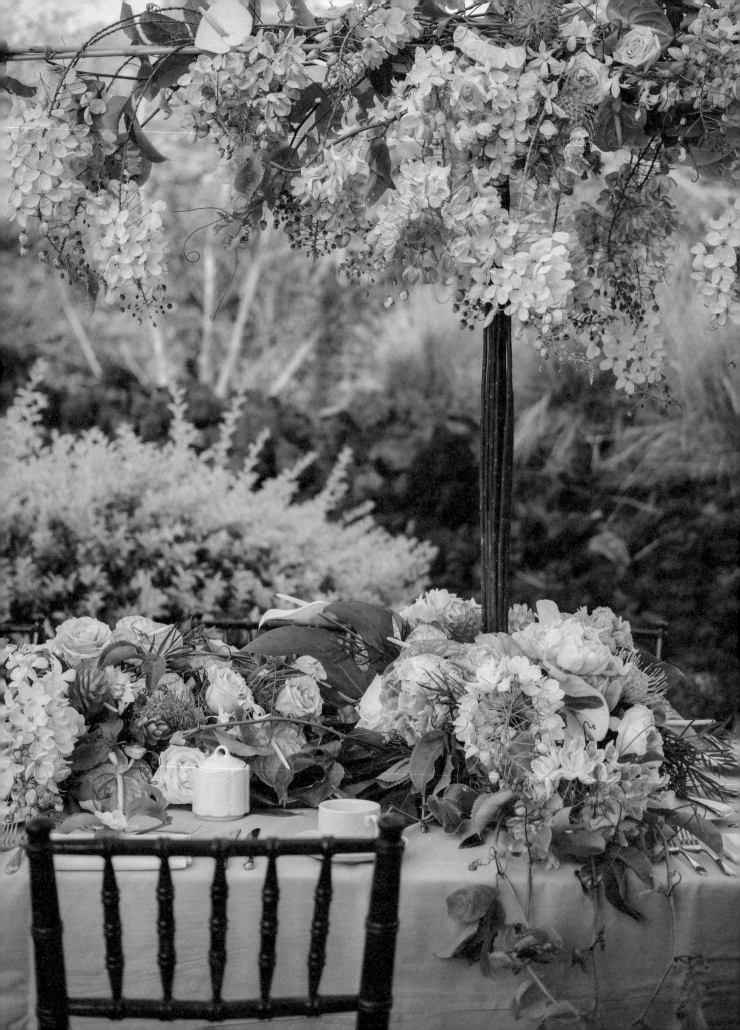

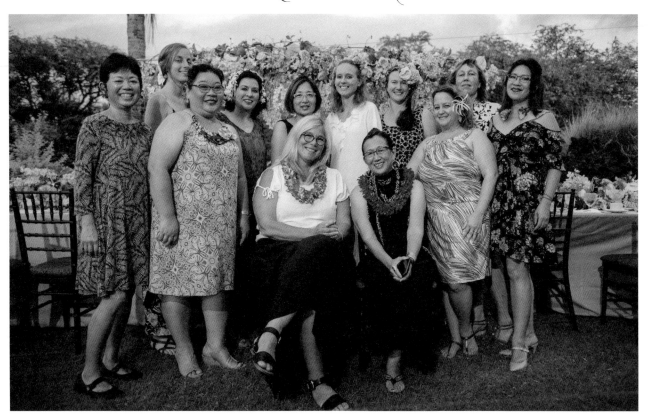

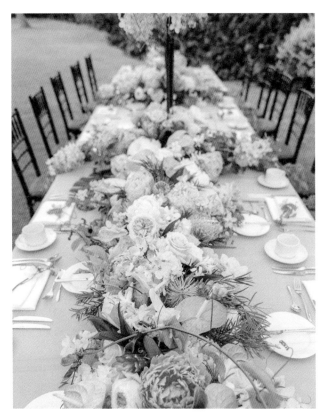

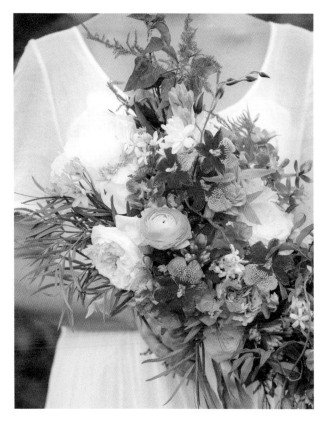

The MidPac Horticultural Conference & Expo is hosted annually by the Hawaii Export Nursery Association,
where Holly is invited regularly as a speaker. There, she joined renowned floral educator Hitomi Gilliam, AIFD, to lead a workshop
incorporating tropical Hawaiian-grown flora and garden roses.

COLIN GILLIAM PHOTOGRAPHY

INSTALLATIONS

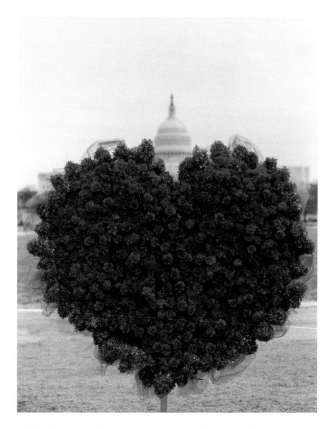

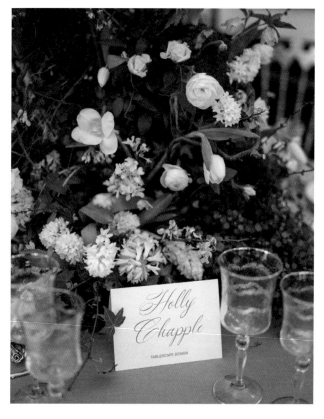

Holly shares her floral talents in support of causes and organizations close to her heart. TOP: At the John F. Kennedy Center for the Performing Arts, peonies to surround the terrace fountains. BOTTOM LEFT: The red floral heart was designed to bring "love" to the nation's capitol on the National Mall. BOTTOM RIGHT: Holly's arrangement designed for the British Influencers Luncheon. RIGHT: Tabletop florals designed for Art in Bloom at the Anderson House in the District of Columbia with Something Vintage Rentals.

TOP: ELMAN STUDIO; LOWER LEFT: THEO MILO PHOTOGRAPHY; LOWER RIGHT: FRED MARCUS STUDIO
OPPOSITE PAGE: CIRCLE LIFE IMAGES

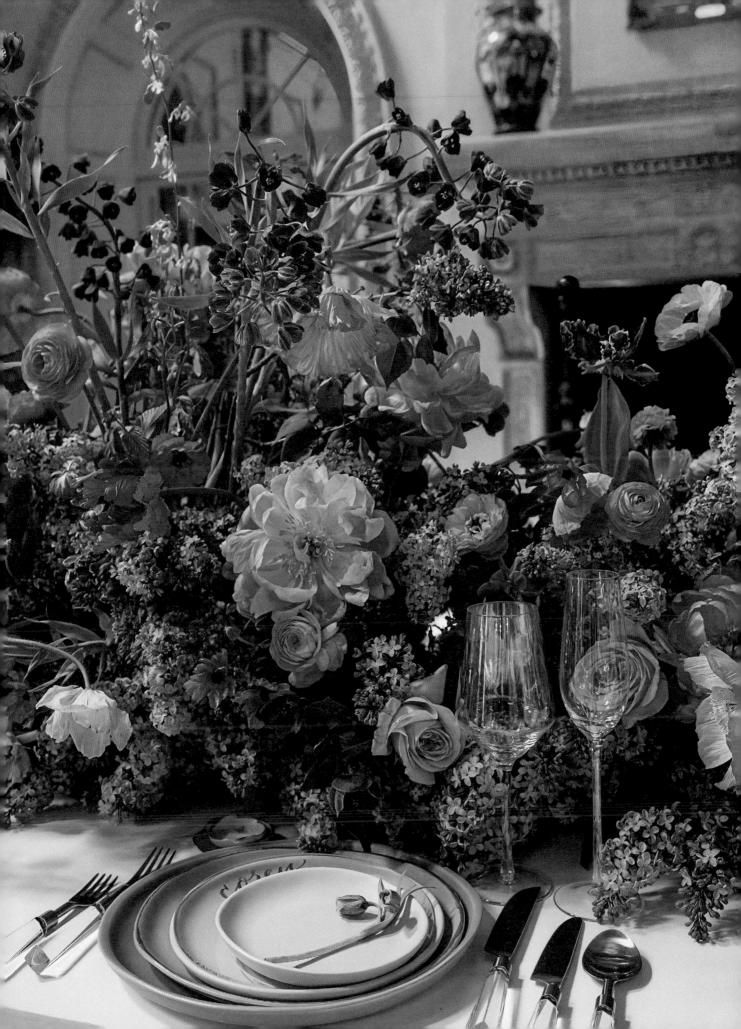

IDEATIONS

"WHEN YOU TRULY FEEL THE IMPORTANCE OF FLOWERS, YOU UNDERSTAND THE VALUE EACH STEM BRINGS TO A DESIGN TO MAKE AN ARRANGEMENT HUM AND SING. THIS IS WHEN YOU CAN FEEL THE POWER OF BLOSSOMS, WHETHER YOU'RE THE DESIGNER OR THE OBSERVER."

Floral ideations come to life when the spark of inspiration takes hold in my mind. An original impression may begin with a color palette, a flower of the season, a dreamy setting, or even a mechanic or product I want to highlight. When the concept becomes a reality, the work is documented and released for publication or shared on social media. This allows me the opportunity to be a part of new trends. Sometimes, an ideation emerges from a client's request to use my aesthetic approach to showcase a particular product, botanical element, or brand. Other times, the ideas come to me uninvited and, in turn, I willingly respond to the muse.

The entire experience is thrilling: to conjure visions and vignettes that begin in my imagination, and then to translate ideas into a three-dimensional installation. The practice gives me the opportunity to create without boundaries. If I'm not being told by a client or couple what palette to use, my mind wanders and comes up with ideas and concepts that feel new to me. I mix and match colors and try to bring together a new expression, something the floral industry hasn't necessarily seen -- and something new, even to me. When left to my own devices, it's full throttle creativity.

For partnerships, collaborations, and client commissions, I'm usually guided by a creative brief -- but even then, I don't feel restrained. It's my responsibility to bring a brand or a stylistic theme to life and I push myself to express new ideas even within parameters, always adding my interpretation to the design.

Sometimes ideations bubble up in my imagination when I have leftover flowers. They simply demand my attention and I'm compelled to create something new. I am often invited to design at a special location, drawing influences from that venue's architecture or environment. But Hope Flower Farm is indeed my best source of inspiration. The spaces of Hope's Manor House invite myriad scenes, much like theater. The mantle over the fireplace, the railing and balusters of the staircase, the dining room's trestle table, the mellowed patina of the stone -- these elements all lend context to my ideations.

True confession: I dream in flowers. My floral ideations open a door welcoming others to enter and experience my imaginary worlds and, I hope, inspire their own creativity.

Holly designed and led a workshop for 50 students, creating a lush, elevated tablescape
at Florabundance Design Days in Santa Barbara, California.

MINETTE HAND PHOTOGRAPHY

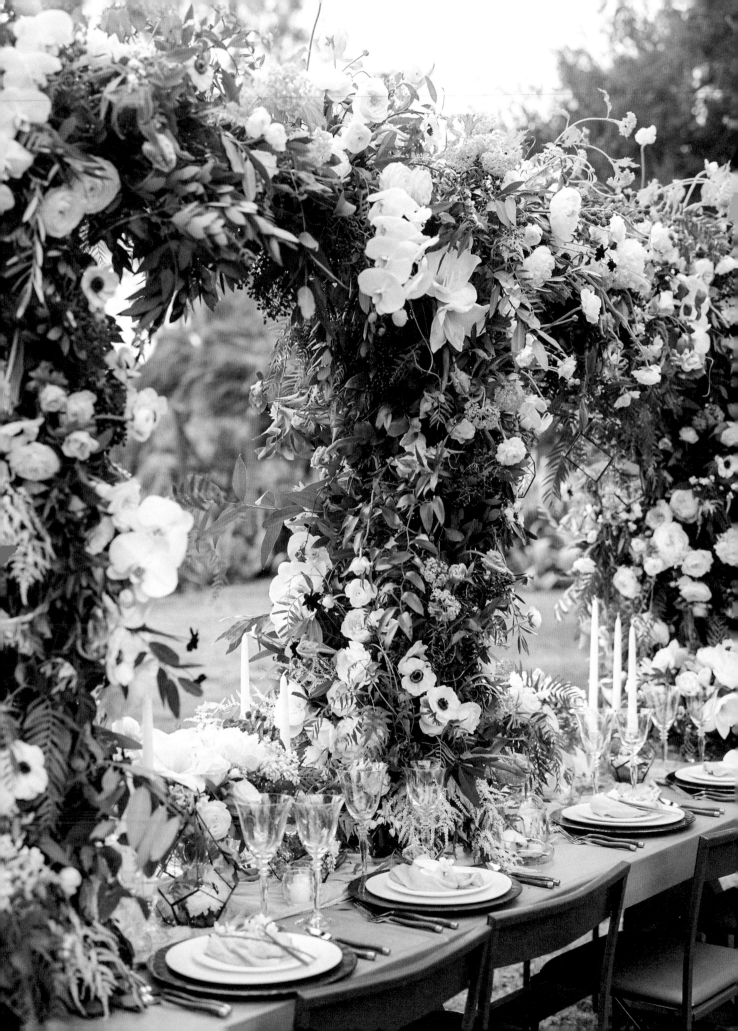

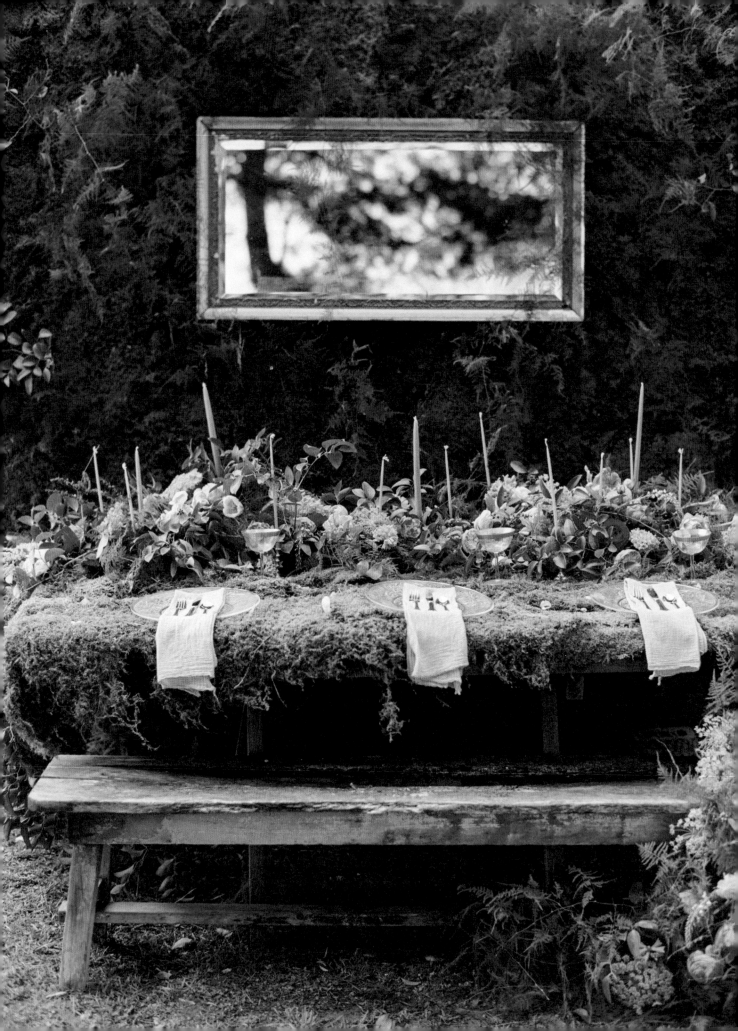

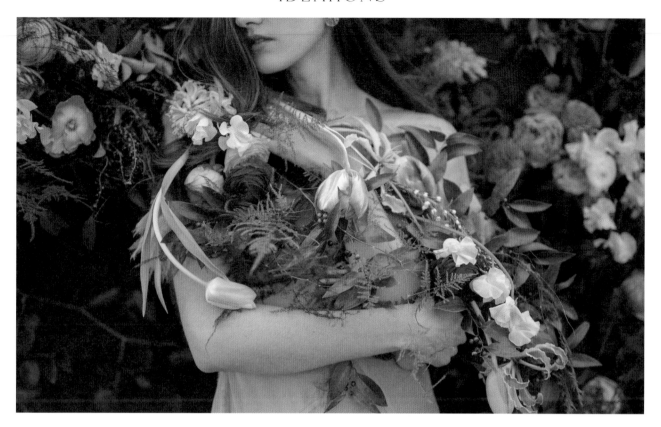

A spring-inspired installation at Hope Flower Farm features a botanical wall with moss, ferns and florals.
The floral runner adorns the moss-cloaked tabletop and reappears as a three-dimensional
component of the wall, encircling a model.

JODI + KURT PHOTOGRAPHY

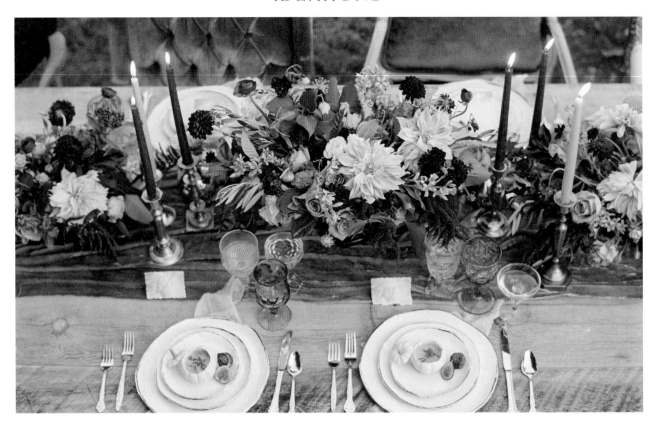

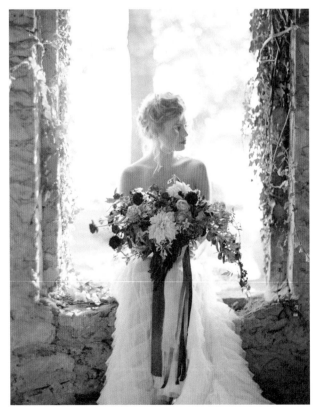

A creative collaboration with Dawn Crothers of Something Vintage who styled
this lovely tablescape at Goodstone Inn in Virginia.
Holly selected a blush, plum and teal palette to echo the unique vintage seating collection.

ANNE ROBERT PHOTOGRAPHY

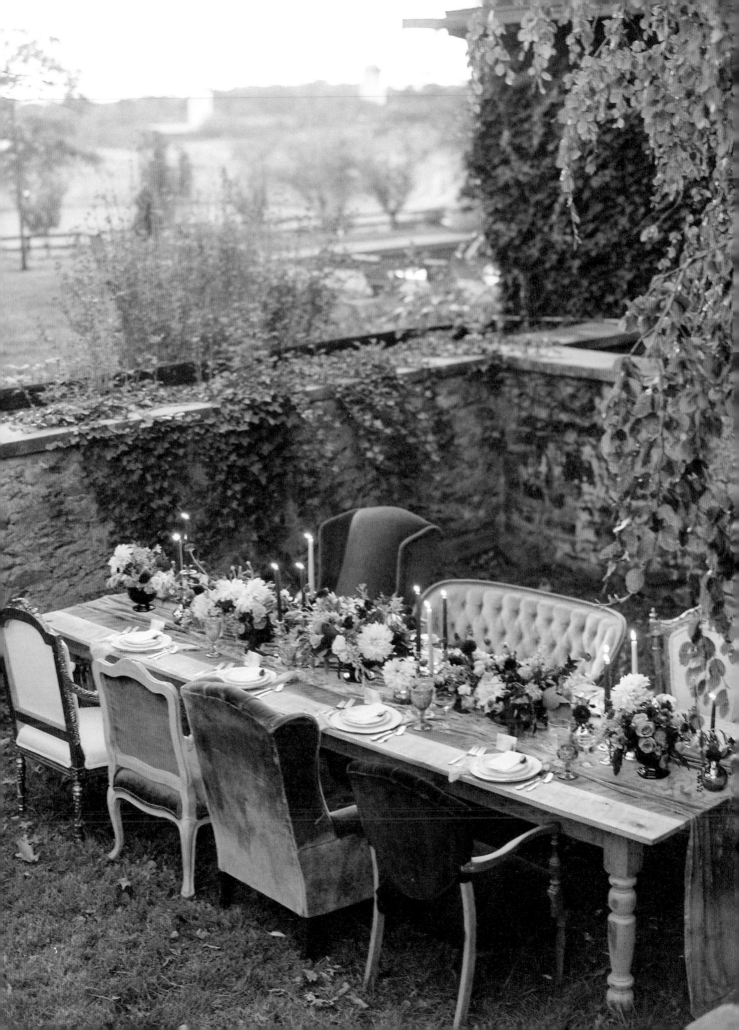

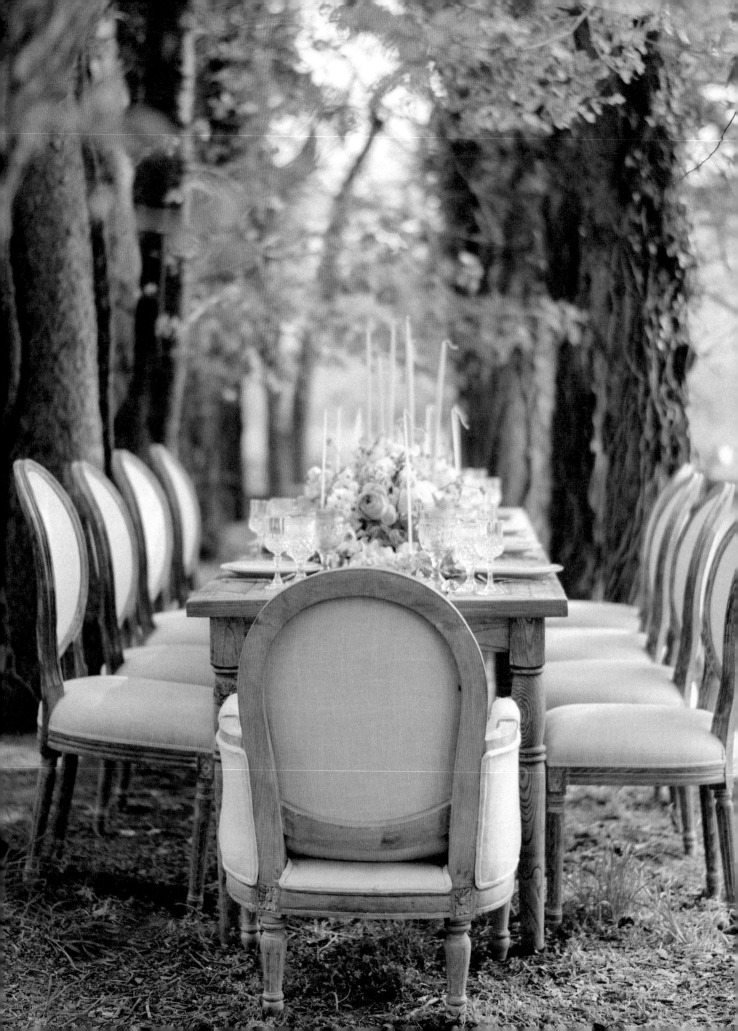

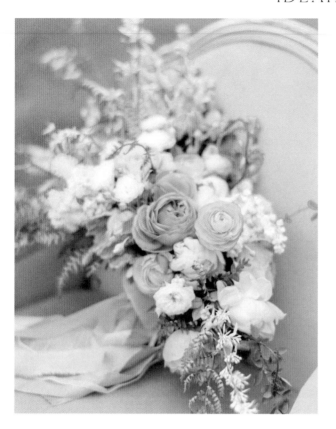

Hope Flower Farm was the venue for this styled shoot with Pop the Cork Designs. Chapel Designer Denise Beaver of Simplicity Floral joined the event for a designer's intensive training. The installation realizes Holly's dream of placing a dining table among an allée of trees, adorned with a spring floral palette.

LIZ FOGARTY PHOTOGRAPHY

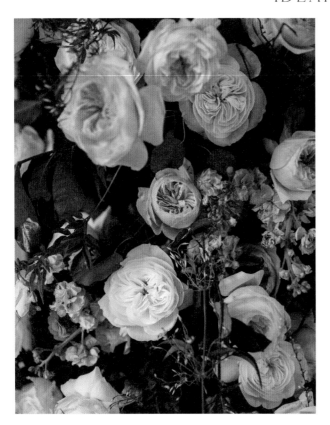
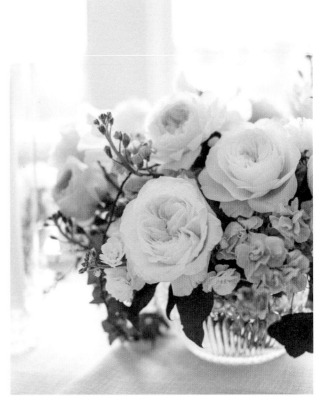
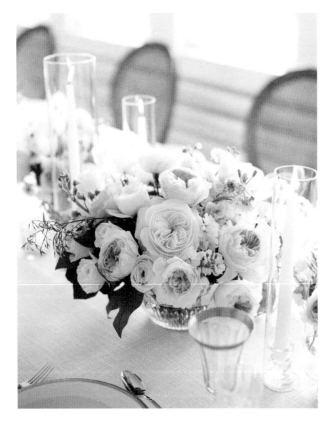
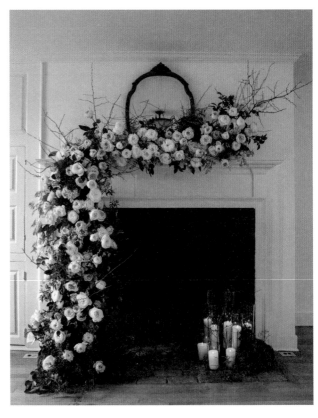

David Austin Wedding Roses commissioned Holly as a brand stylist for this romantic styled shoot at Hope Flower Farm's Manor House. The designs tell the story of intimate nuptials celebrated with 'Juliet', 'Lenora,' and 'Purity' roses, which adorn tabletops, the fireplace mantel, and the staircase.

THEO MILO PHOTOGRAPHY

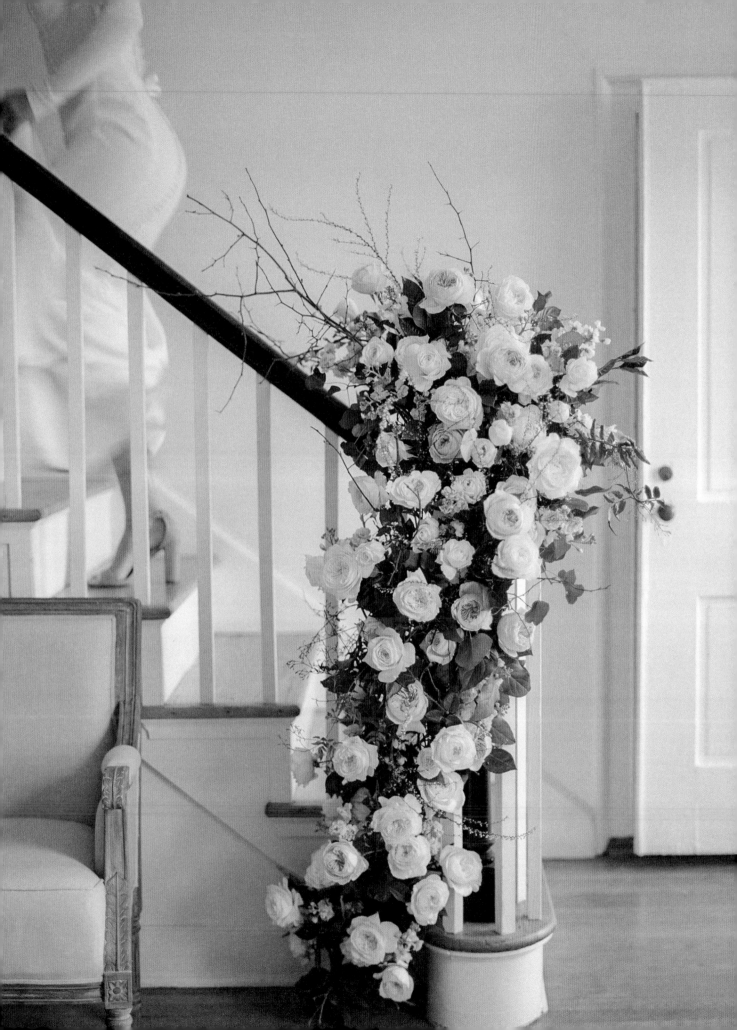

"FOR PARTNERSHIPS, COLLABORATIONS, AND CLIENT COMMISSIONS...
IT'S MY RESPONSIBILITY TO BRING A BRAND OR A STYLISTIC THEME TO LIFE
AND I PUSH MYSELF TO EXPRESS NEW IDEAS EVEN WITHIN PARAMETERS,
ALWAYS ADDING MY INTERPRETATION TO THE DESIGN."

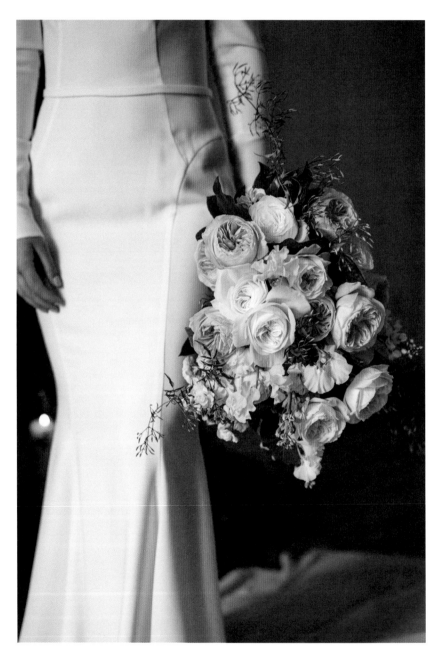

Holly's wedding designs have long featured garden roses, as seen in this lavish hand-tied bouquet
created for David Austin Garden Roses and photographed at Hope Flower Farm.

THEO MILO PHOTOGRAPHY

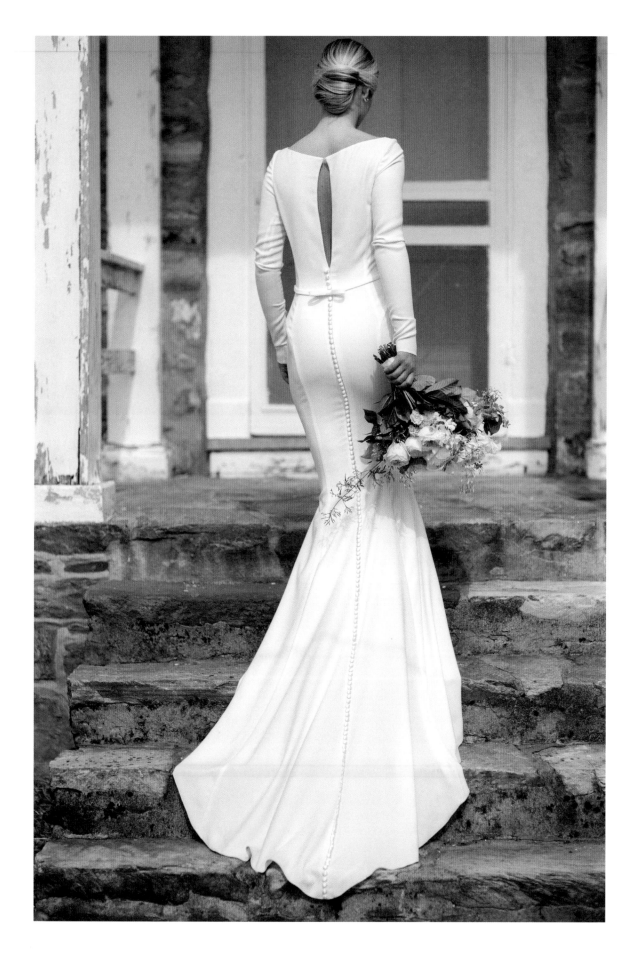

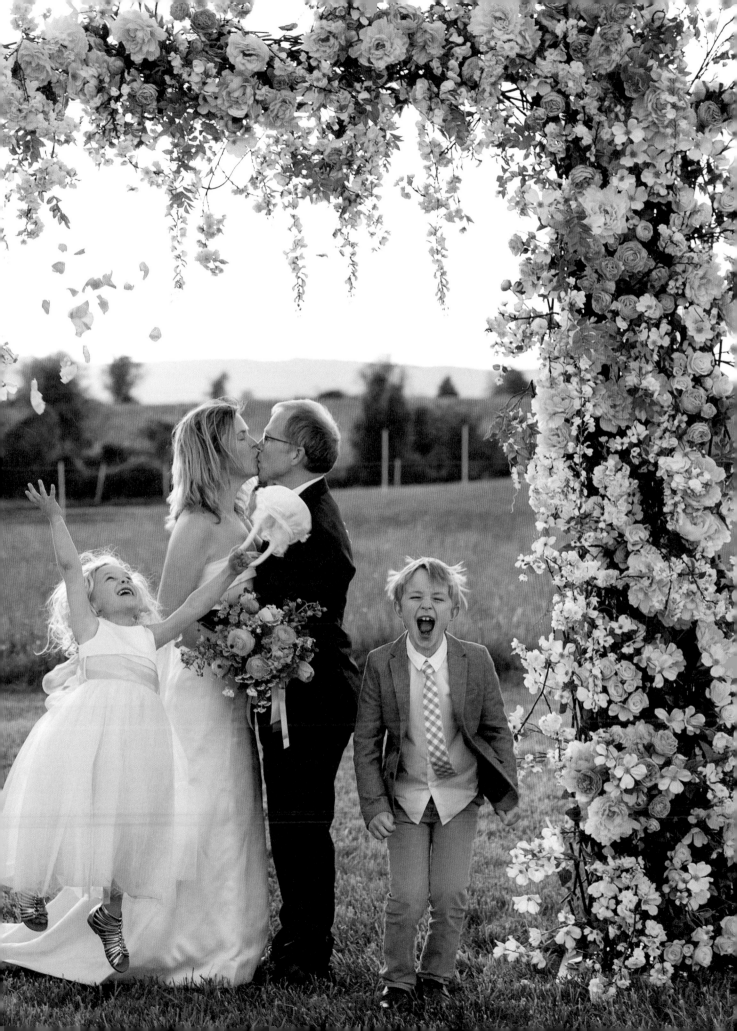

3 INSPIRED GATHERINGS

Every time I embark on designing flowers for a wedding or an event, it's a brand-new experience. It's like my first day on the job because it's my one day to "bring it on!" This single opportunity to do everything in my power to make my clients' special day all they hoped for and envisioned matters so much to me. I am moved heart and soul each time by the opportunity to design a floral setting for their gathering. The experience may be fleeting for everyone involved, but my part helping to create enduring memories fills me with satisfaction and gratitude.

An inspired gathering always begins with understanding the people involved and their heritage, their sentiments, the things they value. Who are they as individuals, as a couple, or as a family? What is their reason for gathering? What are their core beliefs? What is their style? What are their favorite colors or tones? How do they live? I want the event to speak about each family's traditions, to enhance their values, and to feel this in the flowers and throughout the overall design. In the end, my mission is to help build more traditions.

Through the design process, before you know it, all of a sudden, the sweet peas from a bridal bouquet are selected for the baby shower arrangement and maybe, possibly, to signify the passing of a beloved family member. The blooms become a part of each of the family's significant life moments. Flowers add to the family's quilt, woven as part of the threads making up their story. When I take time to explain floral meanings, then choices also become intentional and purposeful for the clients.

My designs require depth in their execution but also in meaning. (If you haven't already guessed, we use these exact words a lot.) By finding and sharing the deeper meaning of the flowers selected, we help everyone feel represented at the gathering.

PREVIOUS PAGES: For their ten-year anniversary, Kristin and Jeff returned to their original wedding designer: Holly Heider Chapple Flowers. This couple was Holly's first full-event wedding commission in 2011 and she happily helped them celebrate the renewal of their vows beneath a stunning floral arch at Hope Flower Farm. AT RIGHT: Florals for Ivy and John include a vivid bouquet to coordinate with the dramatic moon arch, with event stylist/planner Margo Fisher of Bright Occasions.

ABBY JIU PHOTOGRAPHY

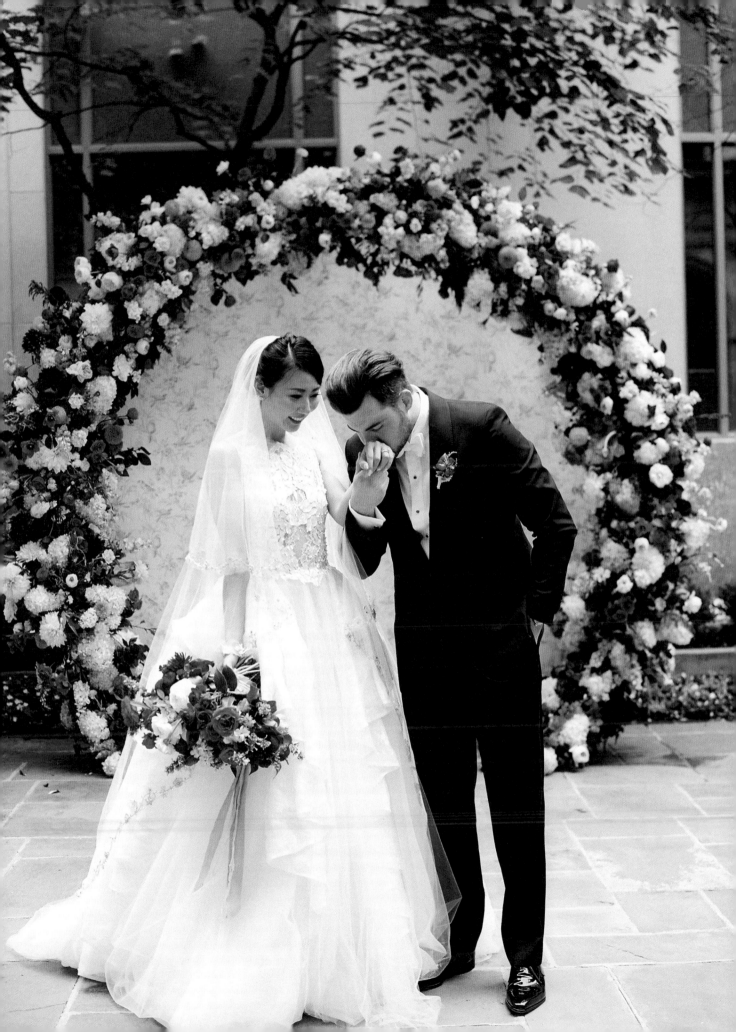

"PEOPLE COME TO US TO DESIGN FLOWERS AND EVENTS FOR THEIR PRECIOUS MOMENTS, OFTEN THE MOST SIGNIFICANT MOMENTS OF LIFE. I AM COMMITTED TO FINDING AND HIGHLIGHTING THE THREADS CONNECTING AND TELLING A STORY, THE LINKS ALLOWING GUESTS TO TRULY EXPERIENCE A COUPLE OR THEIR FAMILY."

When working through the exploration phase with clients, I'm able to extract insights and tidbits of their story. Listening and observing helps me make distinctive design decisions for each client. My respect for them, my delight in discovering who they are, comes through in the floral designs I create. This is a driving force in my process because if I feel connected to my clients, if I understand their story, it propels my designs to another level.

After having one or more thoughtful, meaningful discussions with clients, my team and I will execute, create, and curate floral beauty. Through this process, it's important to see my client's faces (in person or virtually) and hear their voices as I describe the look, vibe, and pricing. By truly "getting them" I can create magic perfectly embodying who they are and their story. This makes me a designer, not an order taker, which is essential to my goal.

As part of this process, questions about the space or venue include: Where will this event take place and how many people are coming? How will the space help to create the illusion or the vision the client is trying to bring to life? Is it indoors or in a cozy little nook at an inn, complete with candlelight and a fire in the fireplace? The space description leads to decisions about furnishings and other elements.

As an event designer we also make decisions about chairs and tables and determine how much light is in a space, along with the width and size of the tables. My team will measure how much room there is between the chandelier and the top of the table. I often ask, "Is the table beautiful enough on its own, or do we need to add linen or velvet?" I consider the vessel for the flowers and decide how its style will complement the hues and tones of the flowers. Details and personal touches matter: The candles, the napkin rings, little salt bowls, name cards at each place setting. I look at every element — right down to the napkin fabric, color, and fold.

When we design thoughtfully by doing thorough groundwork, it gives the client more confidence when they're about to host an event or walk down the aisle — because they know with a full, joyful heart what the flowers symbolize and why.

During the decades that have unfolded since the early 1990s when I formed Holly Heider Chapple Flowers, I have produced more than 2,000 events, including weddings to celebrations of life, from the small and intimate event to the grandiose. No matter the size or purpose of an event I design, it's guaranteed I will always put my whole heart into the effort.

Details express the personality of individual couples whose wedding ceremonies
and receptions are styled by Holly Heider Chapple Flowers.

TOP LEFT: EMILIA JANE PHOTOGRAPHY; BOTTOM LEFT: KIR2BEN PHOTOGRAPHY;
TOP RIGHT: LIZ FOGARTY PHOTOGRAPHY; BOTTOM RIGHT: ABBY JIU PHOTOGRAPHY

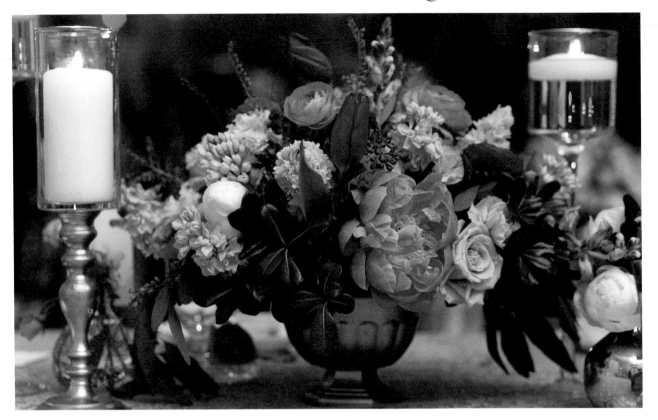

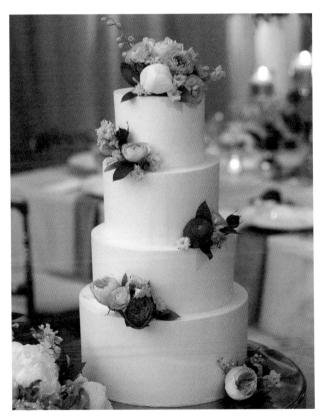

A Chicago ballroom is transformed into a rose and peony-filled botanical garden
for the wedding celebration of Bridget and Lou, with floral design and event styling by Holly Heider Chapple
and planning by Allison Young of LK Events.

EMILIA JANE PHOTOGRAPHY

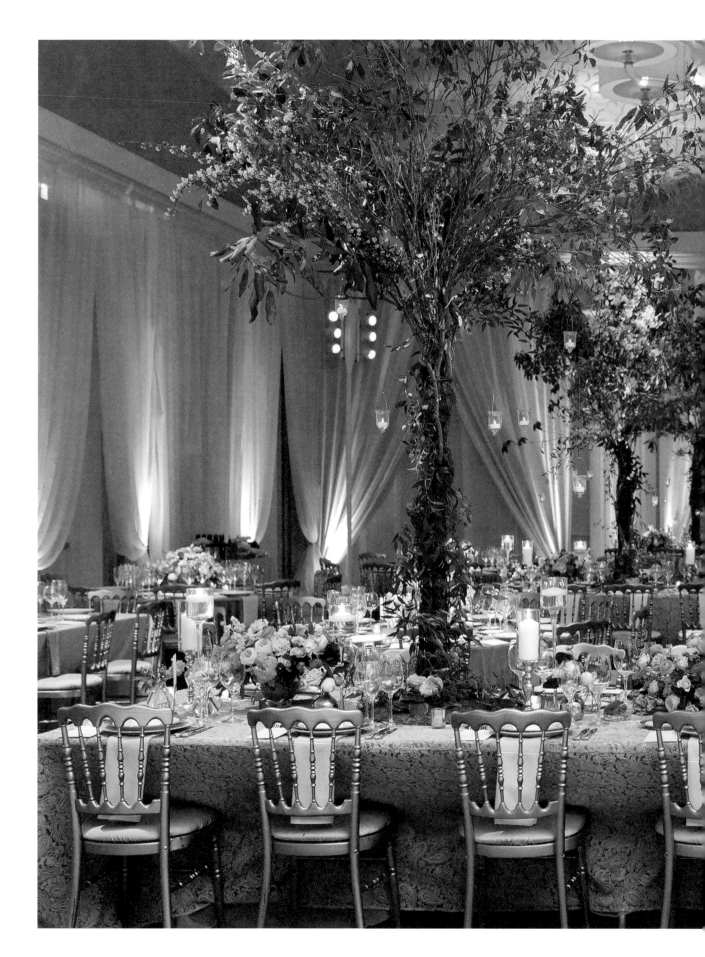

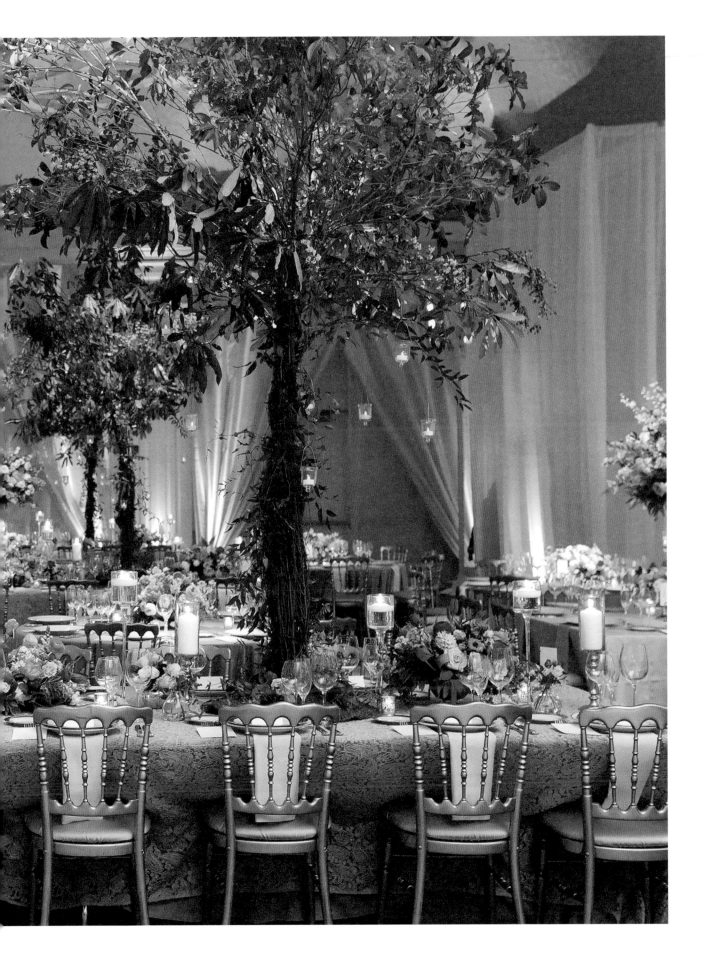

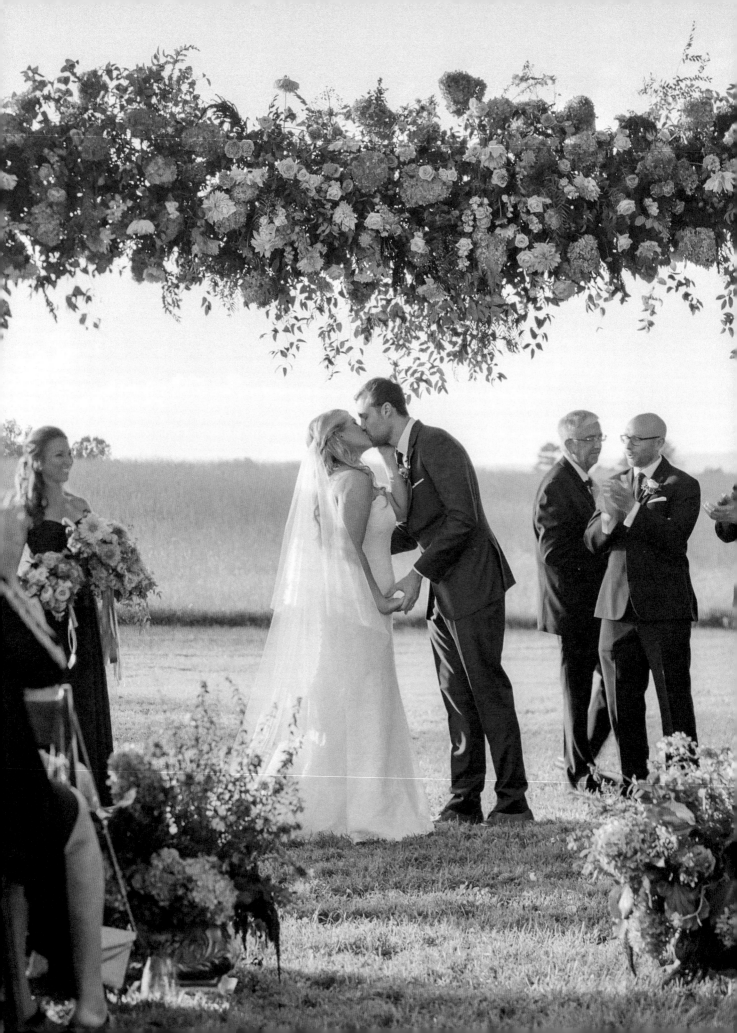

FARM ROMANCE

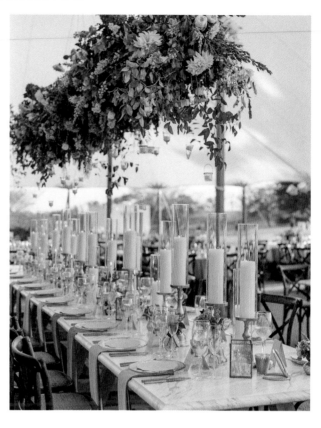

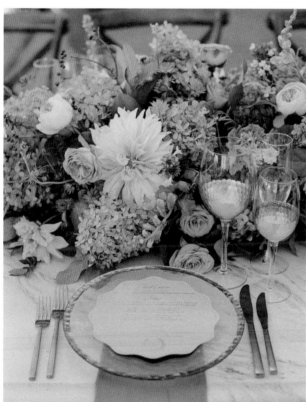

Elise and Dan say vows beneath a 22-foot-long flower canopy featuring limelight hydrangea and dahlias,
with floral design and event styling by Holly Heider Chapple
and event stylist and planner Kelly Cannon Events.

JODI + KURT PHOTOGRAPHY

CITY SOPHISTICATES

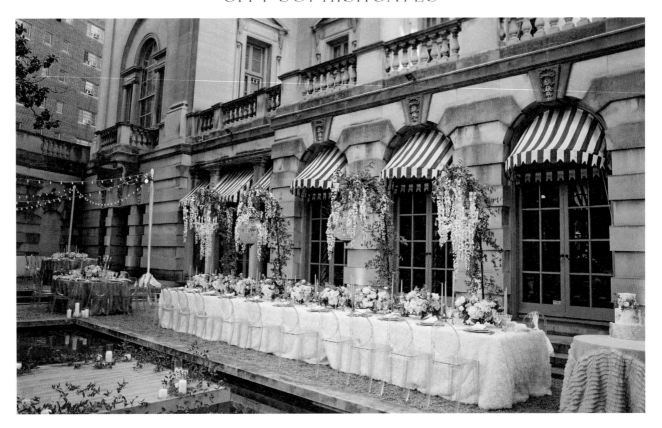

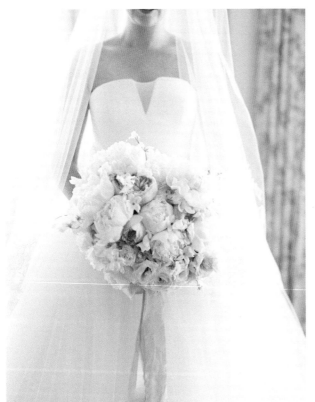

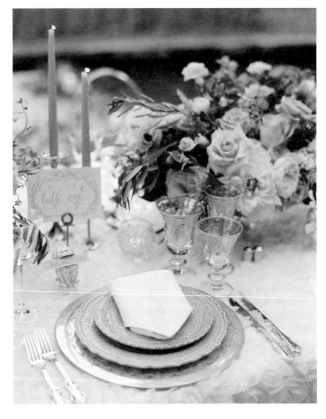

Stephanie and Andy's wedding features a taupe and pale blue palette
embodying the elegance of this historic venue,
with flowers by Holly Heider Chapple and event styling and planning by Lauryn Prattes Events.

ABBY JIU PHOTOGRAPHY

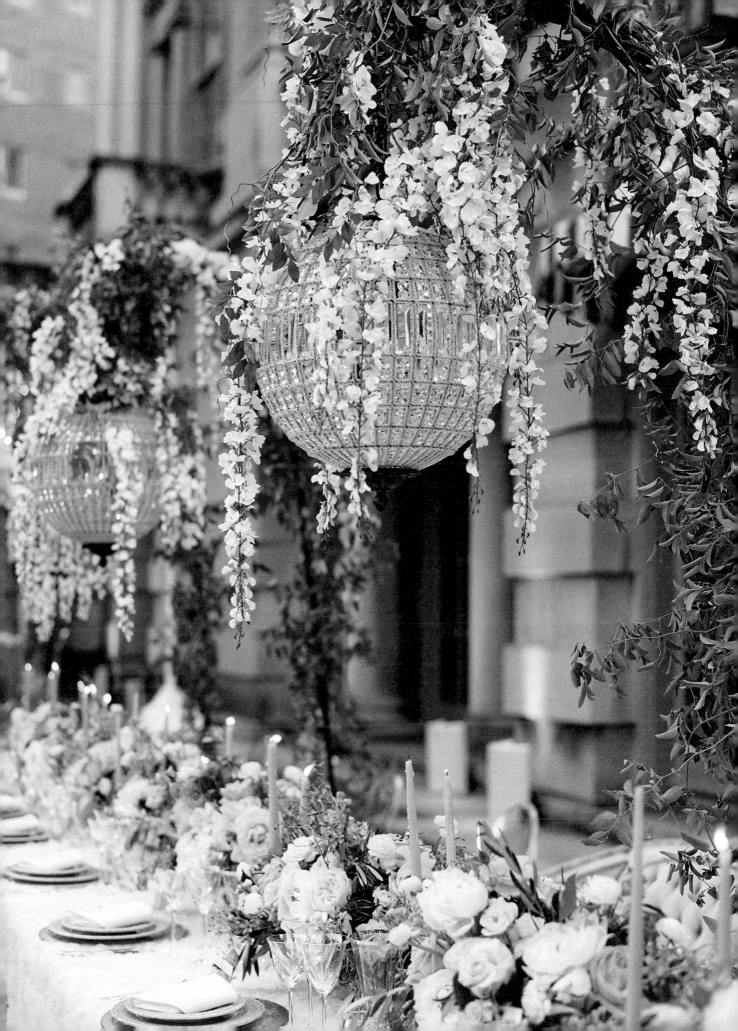

GOLDEN MOMENTS

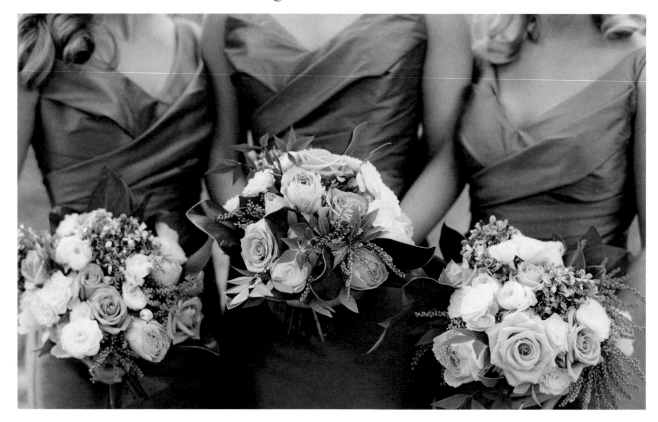

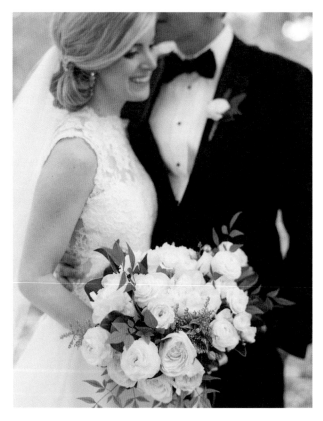

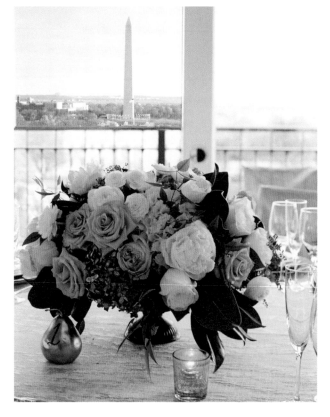

Emily and Chris wed at the top of the landmark Hay-Adams Hotel overlooking The White House,
their floral setting graced with magnolias, gold-tinted hydrangea, pieris, copper nandina, and golden roses
designed by Holly Heider Chapple, with event styling and planning by Lauryn Prattes Events.

ABBY JIU PHOTOGRAPHY

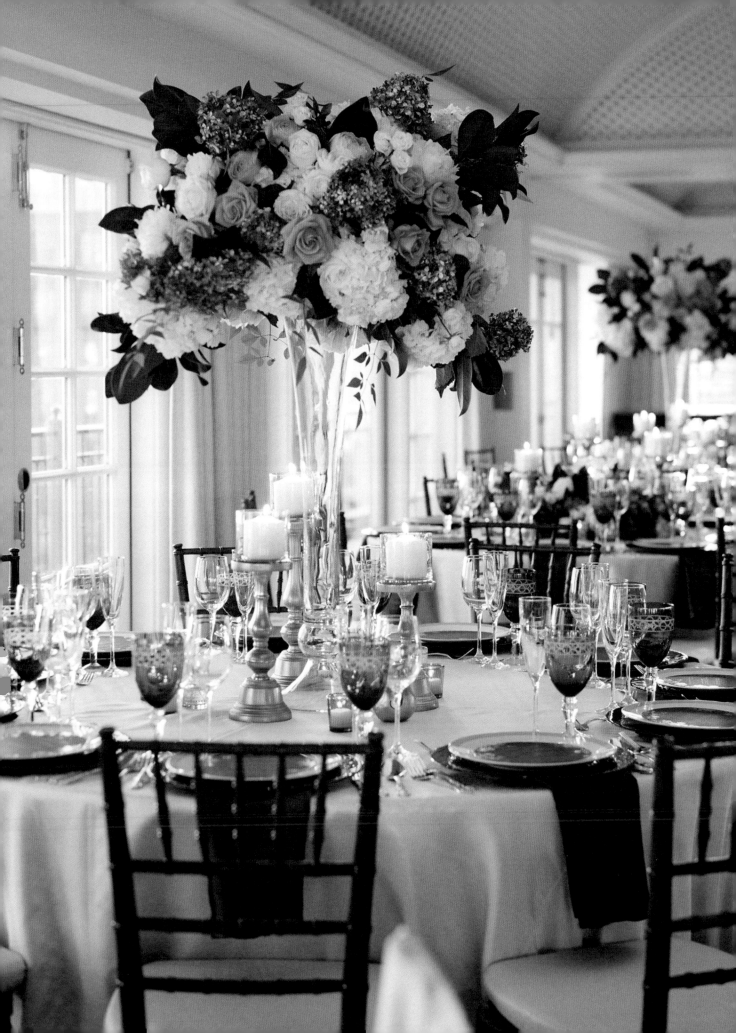

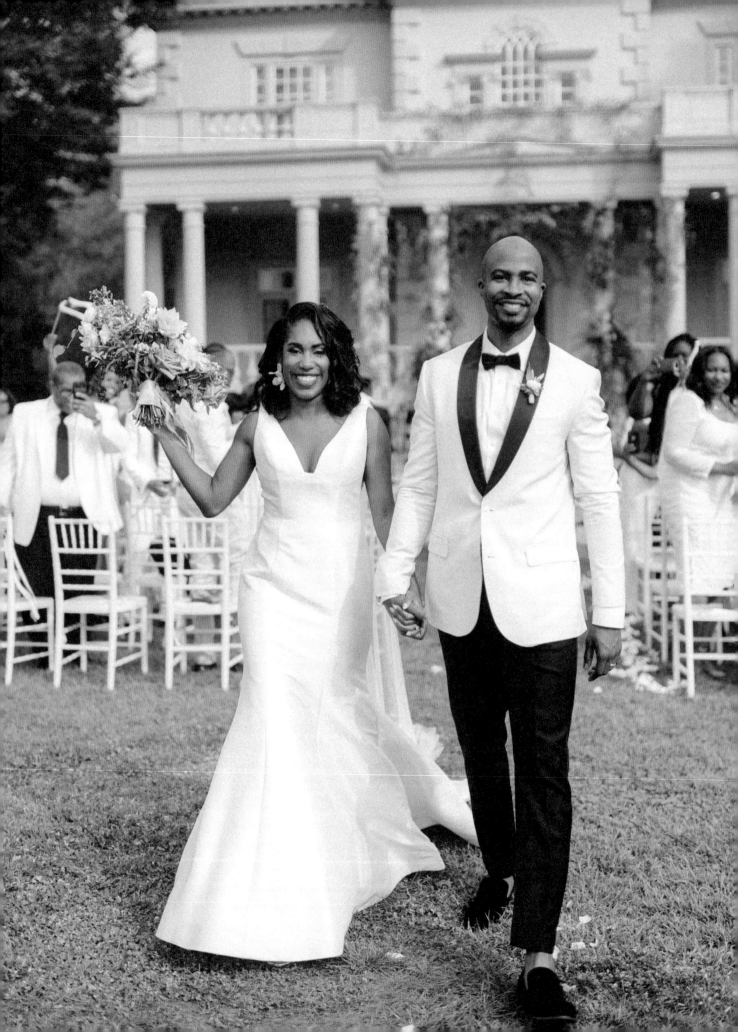

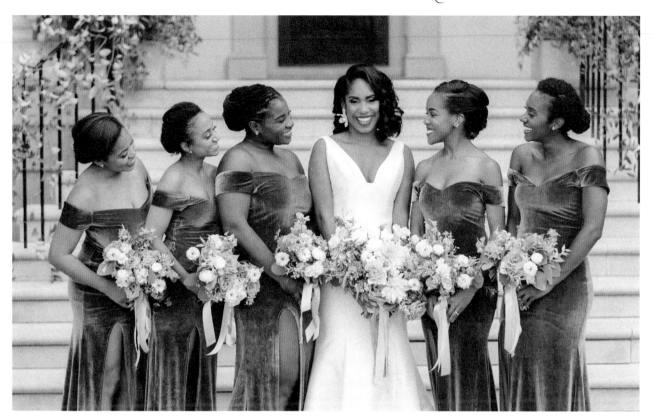

A copper palette for Ericka and TK inspired Holly Heider Chapple to design a floral spectrum with gold,
toffee, pale blue, and dusty pink for a ceremony at the Great Marsh Estate in Virginia. She collaborated with Erin Sok, the bride's twin
sister, who styled the ceremony, and Favored by Yodit, event planner.

LIZ FOGARTY PHOTOGRAPHY

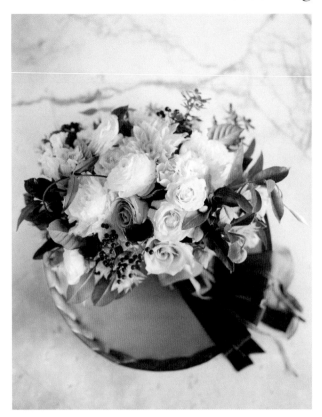
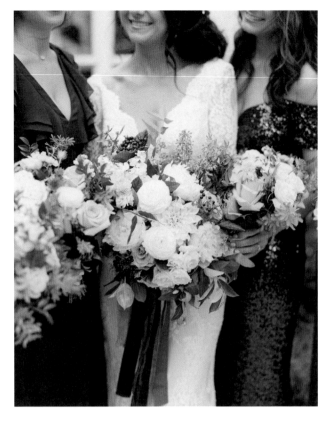
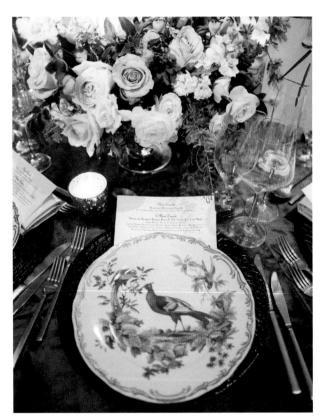

Emerald green foliage paired with velvet for Alana and Daniel's wedding ceremony and reception are mixed with classic white and dusty mauve florals, fresh moss, and smilax vines, flowers designed by Holly Heider Chapple with event stylist and planner Laura Ritchie of Grit and Grace.

ABBY JIU PHOTOGRAPHY

BELOVED MOMENT

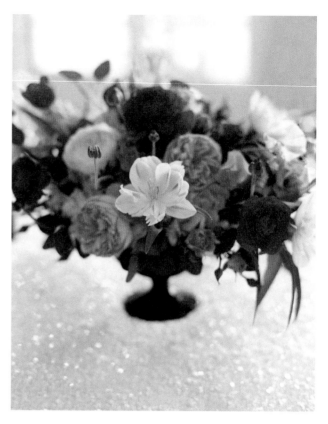

Debby and Laura's joyful ceremony features florals in shades of pink and lipstick red,
with sparkles and black accents, designed by Holly Heider Chapple
with event stylist and planner Lauren Prattes.

LISA ZIESING FOR ABBY JIU PHOTOGRAPHY

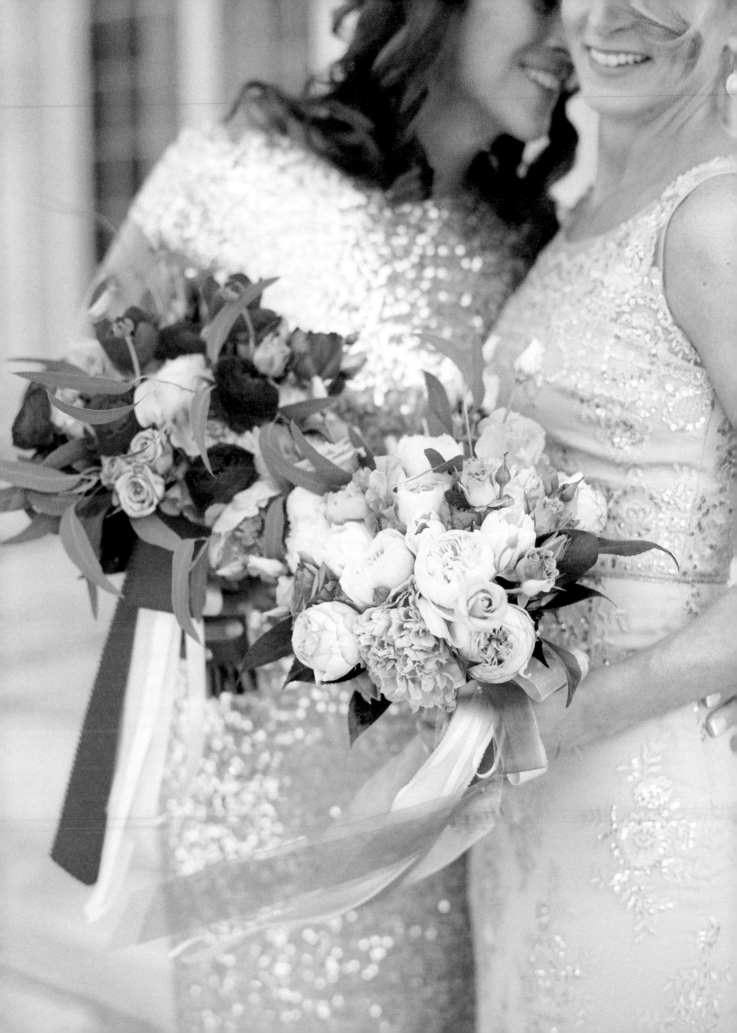

Tom and Ashley wed on New Year's Eve, inspiring Holly Heider Chapple to select phalaenopsis orchids
and glamorous golden vessels to set the tone of formality and elegance,
producing the stunning event with stylist and planner Kelley Cannon Events.

LISA BOGGS PHOTOGRAPHY

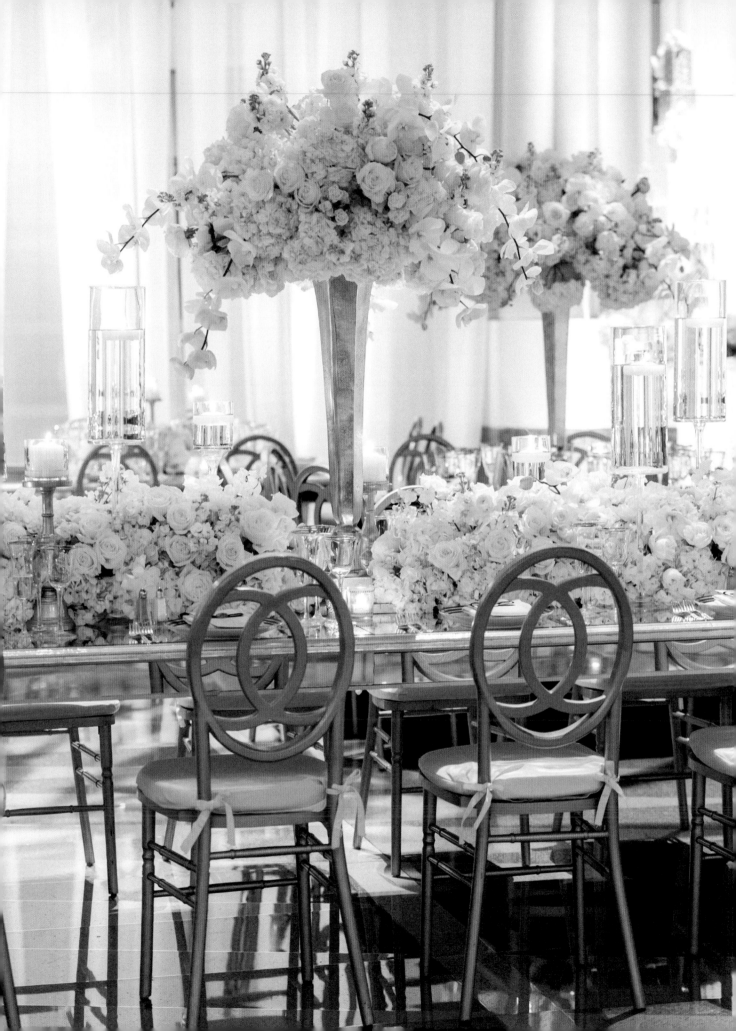

MODERN CLASSIC

Dina and Daniel's ceremony featured hundreds of feet of floral garlands and a hanging structure
of crystals and greenery, with jewel-toned flowers designed by Holly Heider Chapple
with event stylist and planner Pamela Barefoot Events.

AMELIA JOHNSON PHOTOGRAPHY

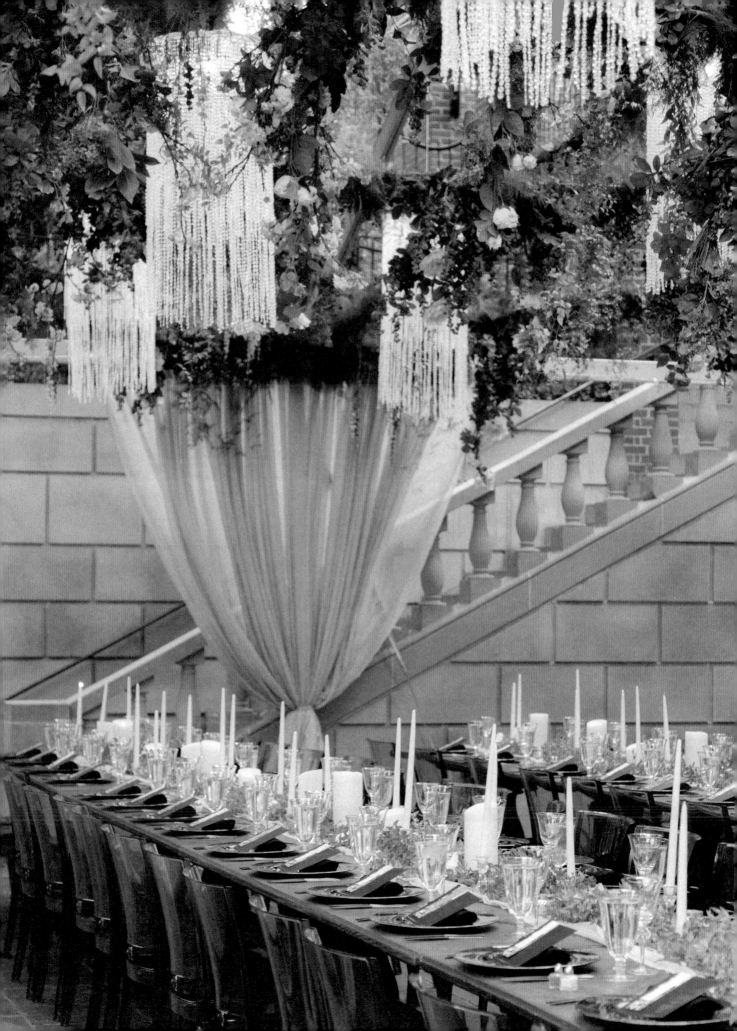

CHERISHED VOWS

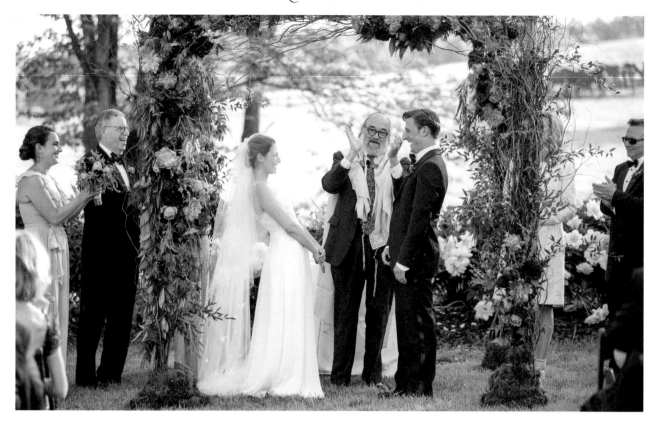

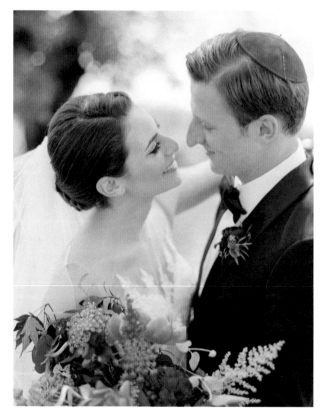

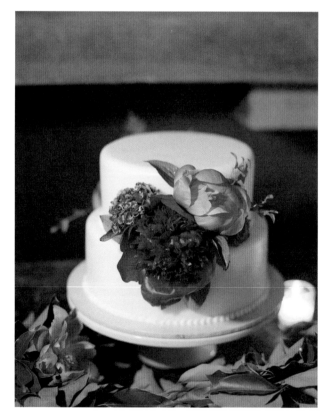

For their outdoor wedding, Sasha and Tyler's spring flowers include peonies, ranunculus, astilbe,
and maple tree foliage, flowers designed by Holly Heider Chapple
with event stylist and planner Kelly Cannon Events.

JODI + KURT PHOTOGRAPHY

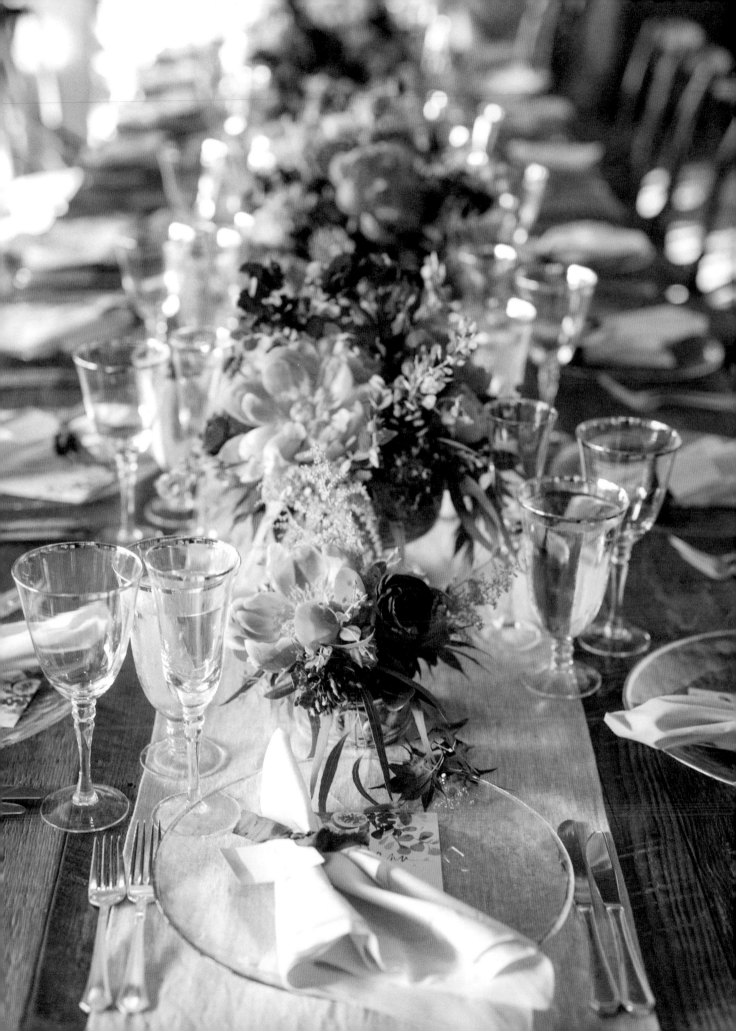

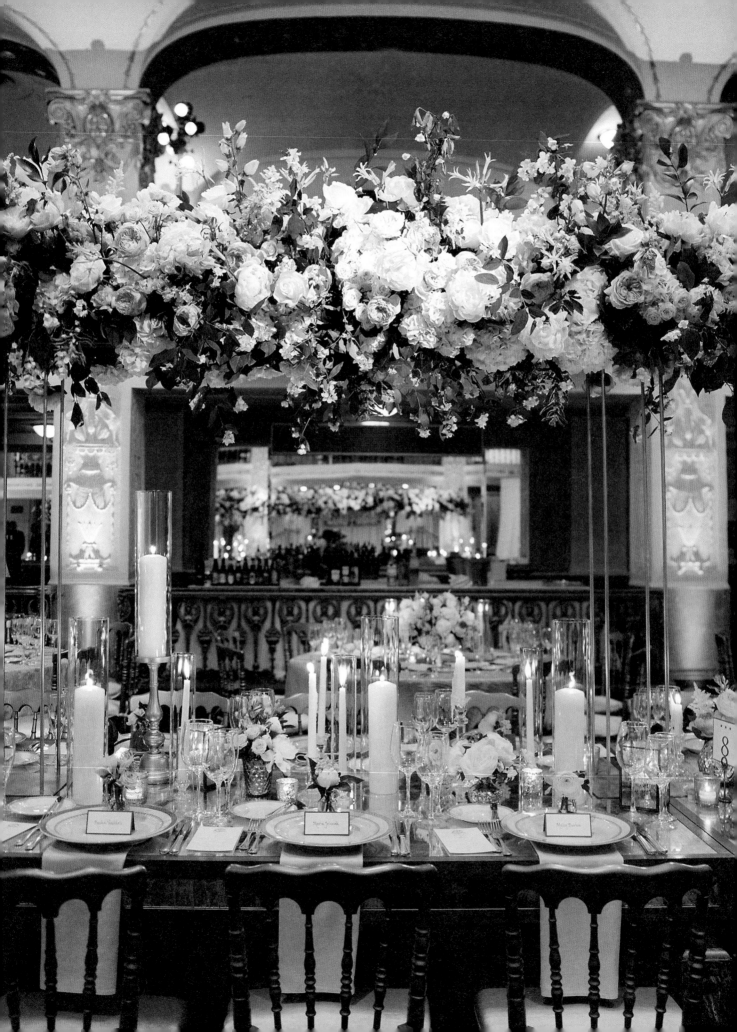

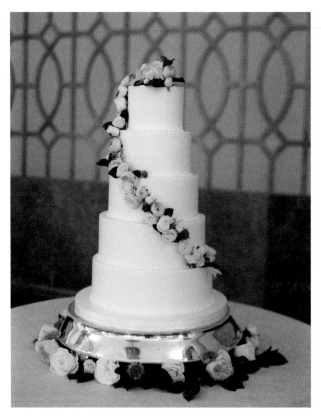

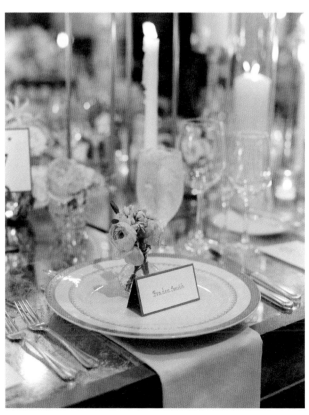

For Meg and Jim's reception, Holly Heider Chapple served as event stylist and floral designer,
creating an epic floral bridge in collaboration with Evan Chapple who engineered the design with Cheers Darling. The soft pink and
white floral palette continued through bouquets, boutonnieres, place settings and a beautiful cake garland.

LISA ZIESING FOR ABBY JIU PHOTOGRAPHY

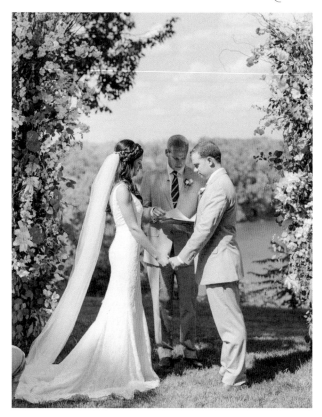
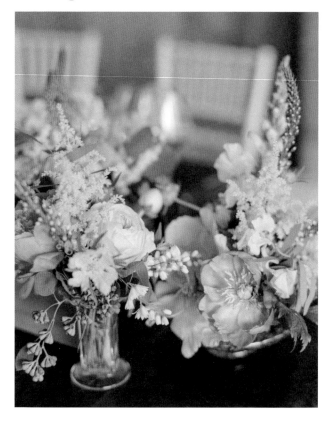
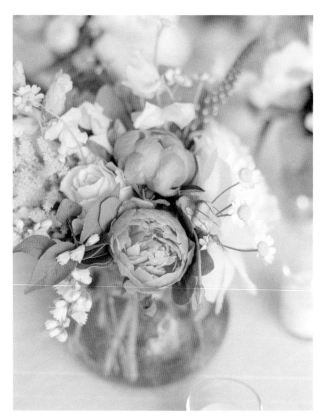

Katie and Scott's happy spring palette of poppies, peonies, sweet pea, snapdragon, chamomile, and deutzia reflects their equally blissful ceremony, with floral design by Holly Heider Chapple, and event stylist Megan Pollard from Grit and Grace.

JODI + KURT PHOTOGRAPHY

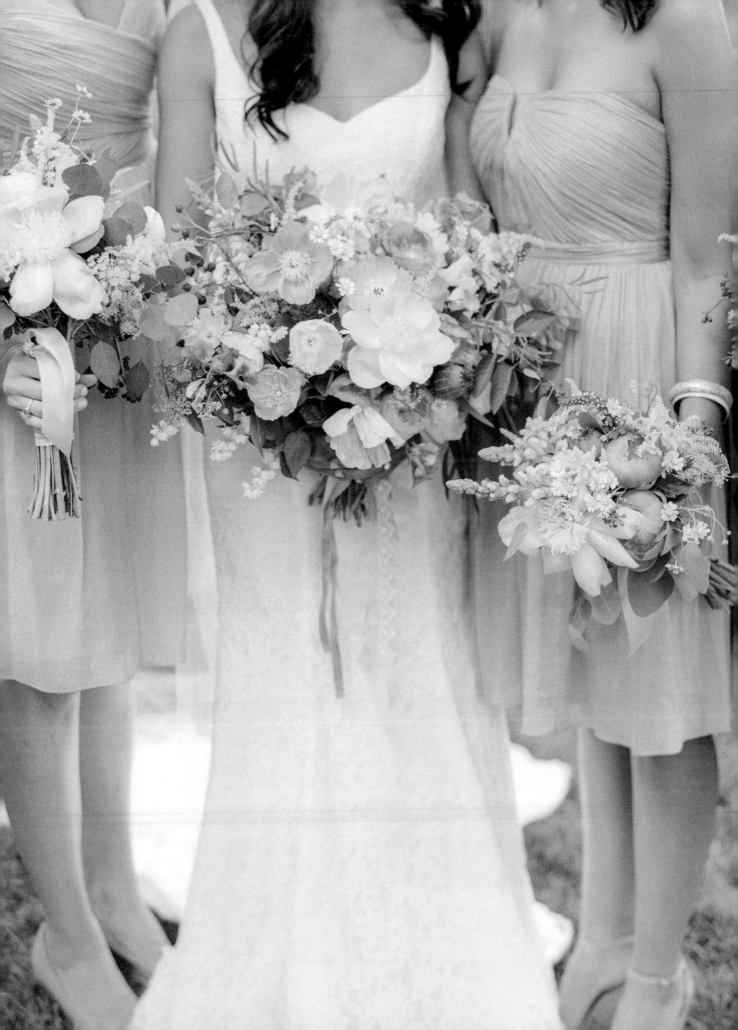

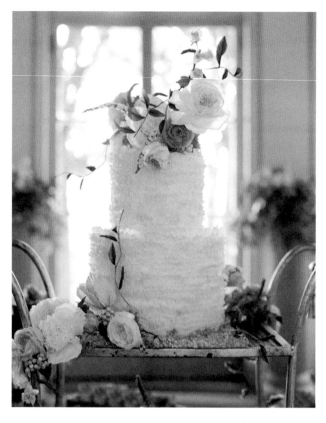

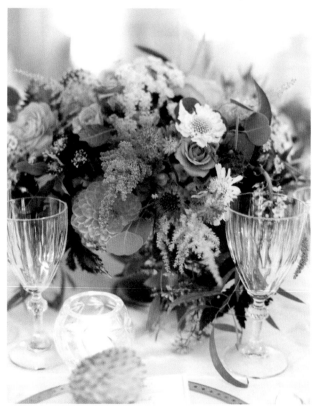

Lee and Jon's boutonnieres reflect the garden-inspired palette of their intimate Washington, D.C., wedding and reception, with event styling and floral design by Holly Heider Chapple and coordination by Megan Pollard of Grit and Grace.

ABBY JIU PHOTOGRAPHY

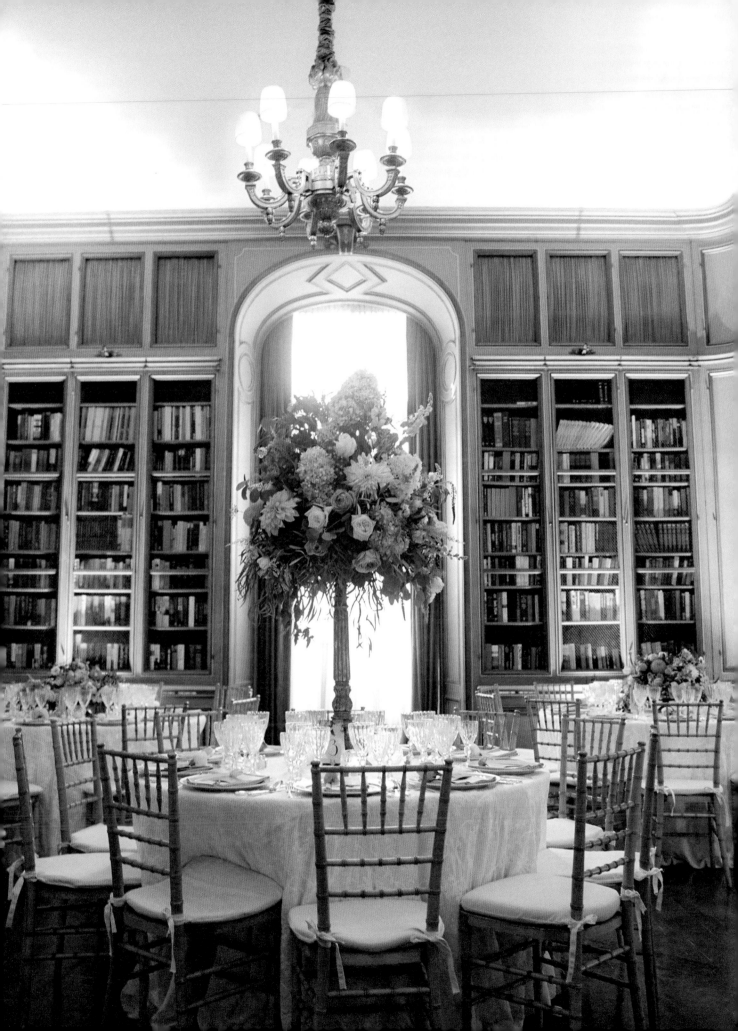

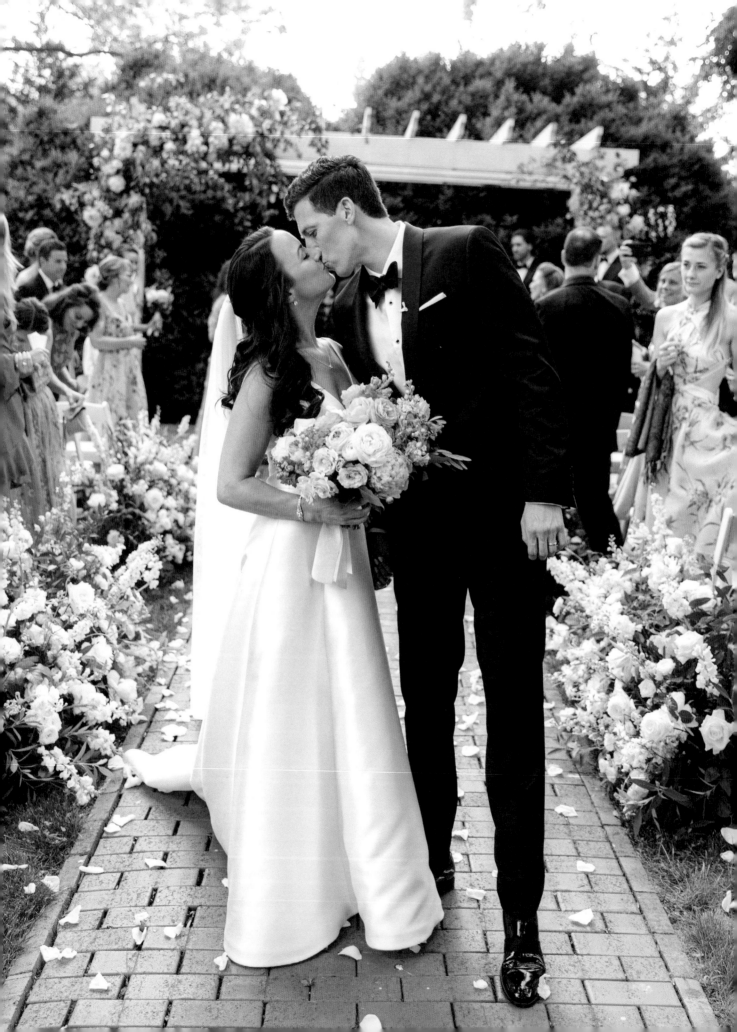

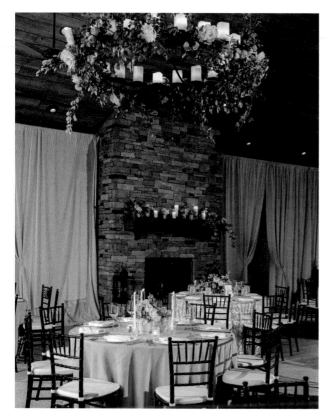
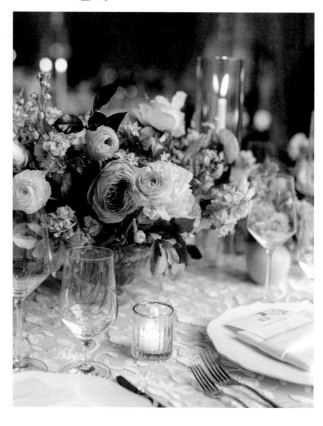
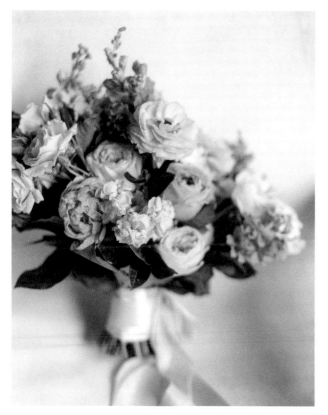

Courtney and John's ceremony features Hope Flower Farm's peonies and ranunculus
in a blush and peach palette, and all-white sprays of blooms along the aisle, designed by Holly Heider Chapple
with event styling and planning by Kelley Cannon Events.

SARAH BRADSHAW PHOTOGRAPHY

JADE · WHITE

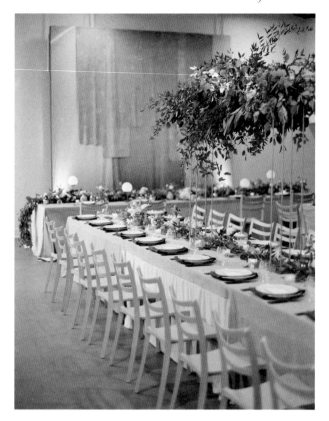

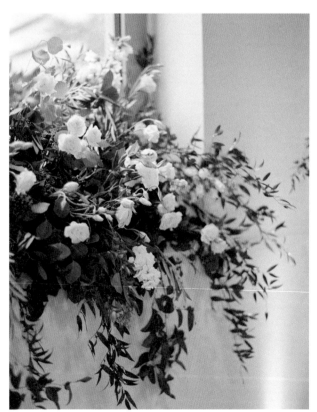
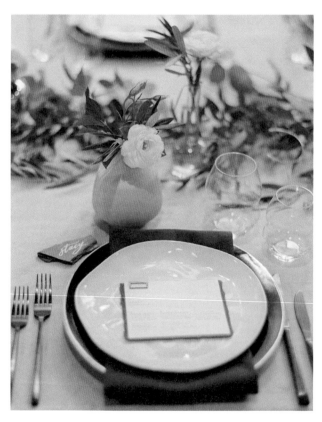

For Megan and Long's wedding ceremony, Holly's friendship with the bride led to a creative collaboration
to design a green-and-white floral palette featuring nerine lilies, white tweedia, and campanula in the bouquet.
Janice Carnevale of Bellwether Events served as event stylist and wedding planner.

VICKI GRAFTON PHOTOGRAPHY

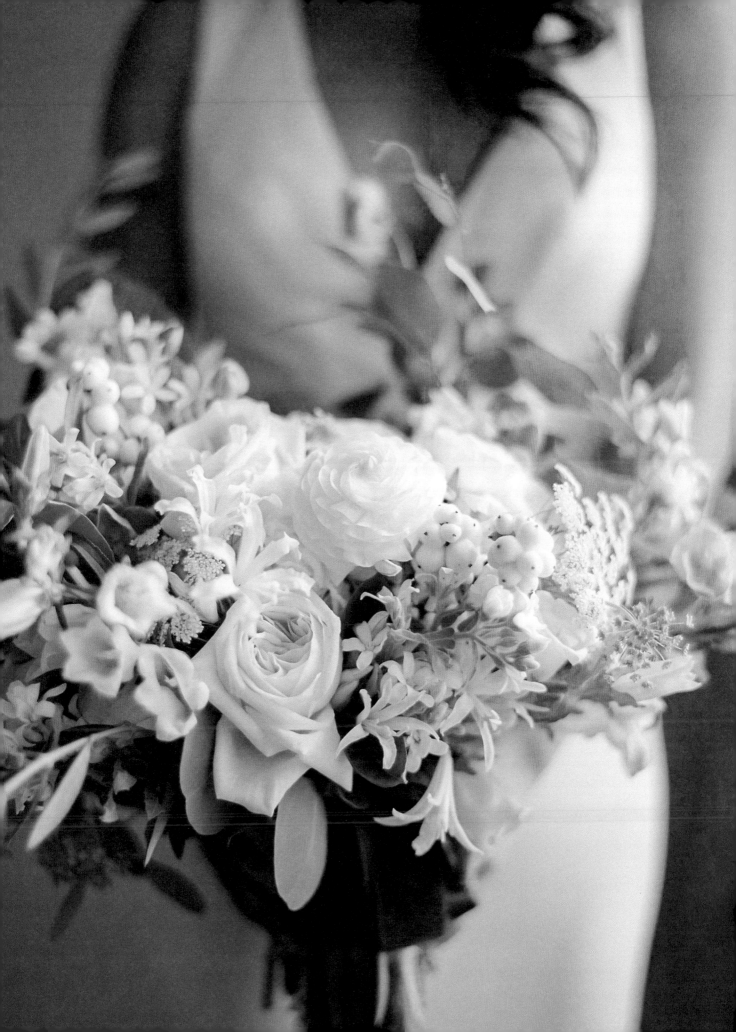

FAMILY HERITAGE

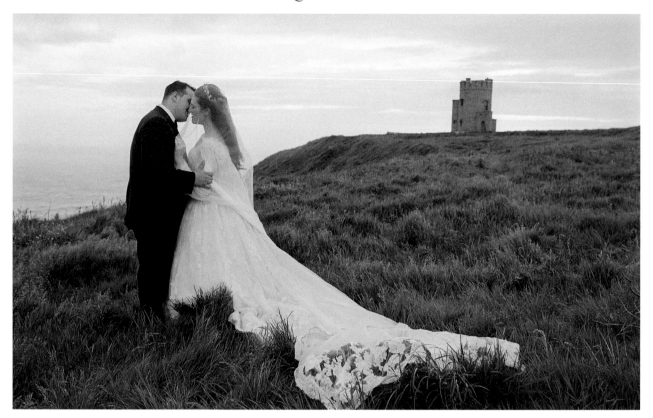

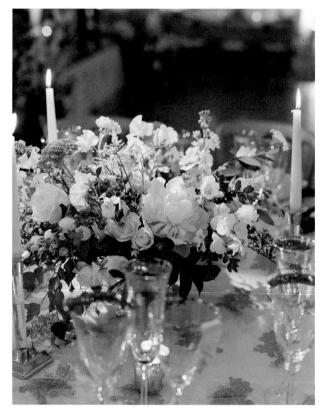

Elizabeth and Matthew traveled to Ireland for their storybook wedding, flowered with roses, campanula, jasmine, English ivy, and other garden-inspired elements. The event included many Irish Chapel Designers who assisted Holly Heider Chapple as the couple's floral designer, with event styling and planning by Lauryn Prattes.

LAURA GORDON PHOTOGRAPHY

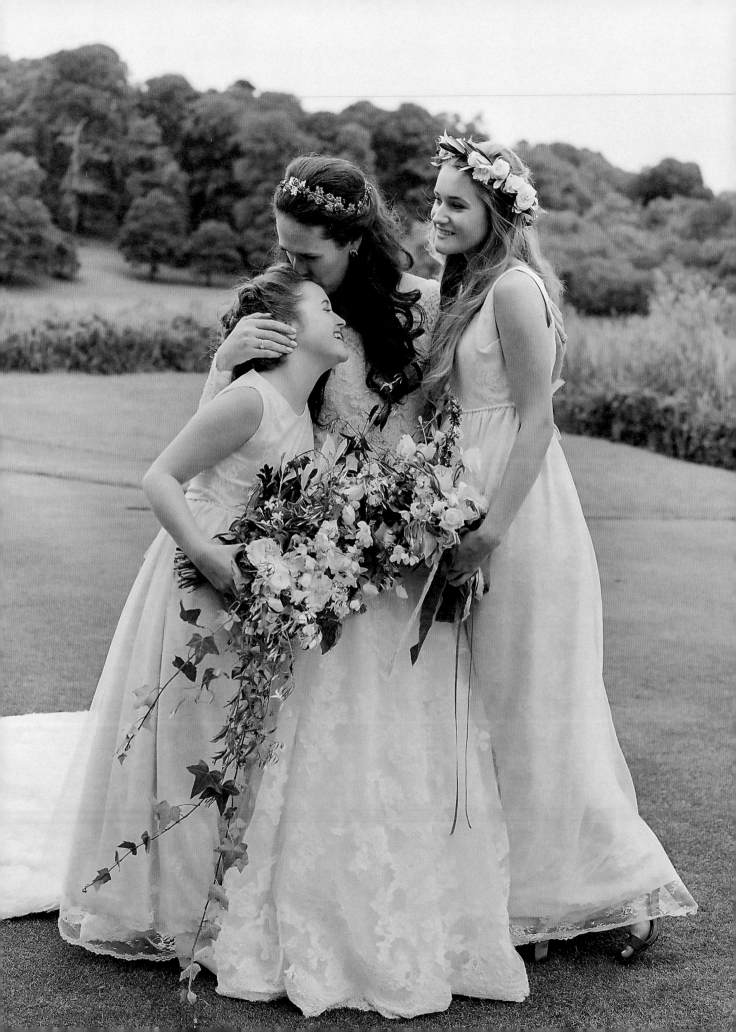

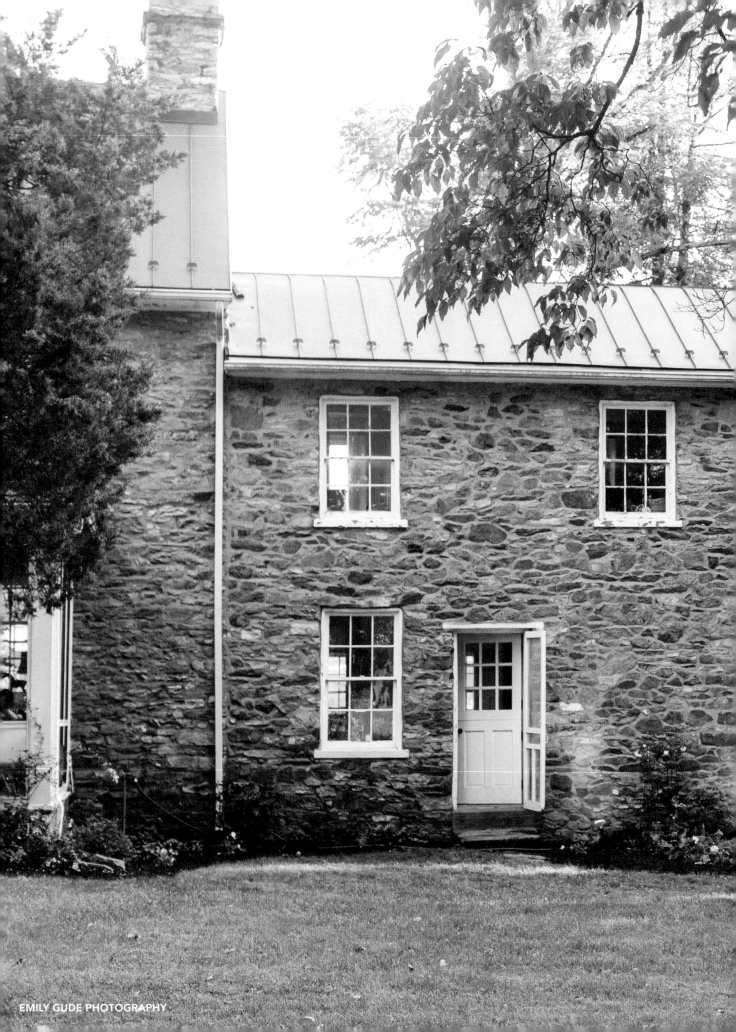

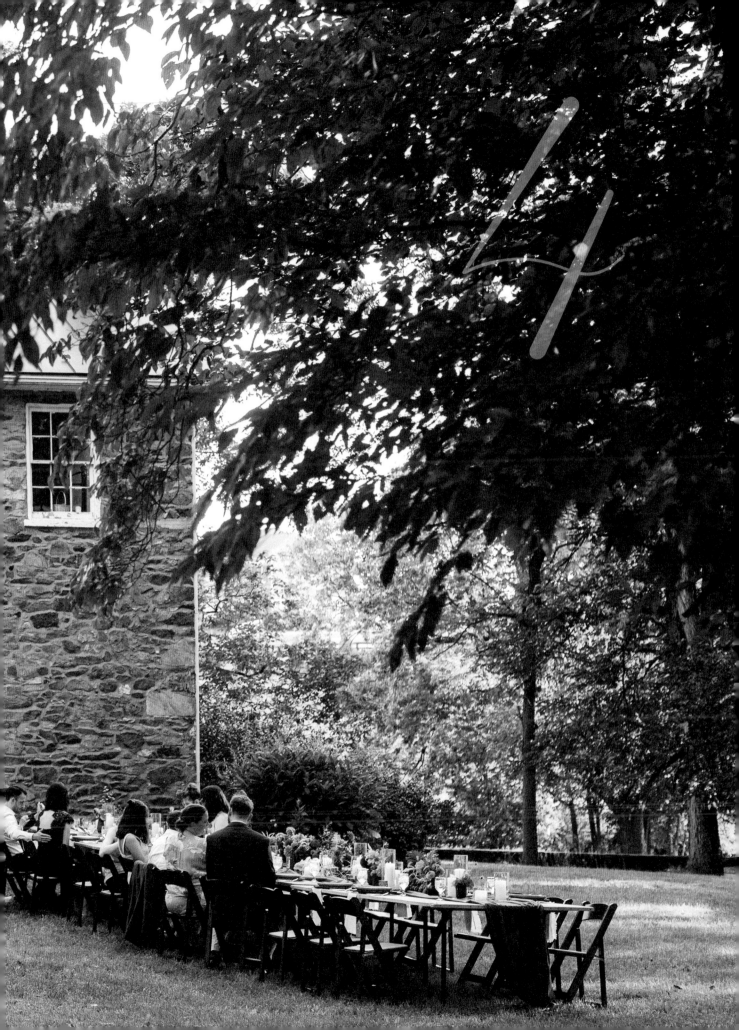

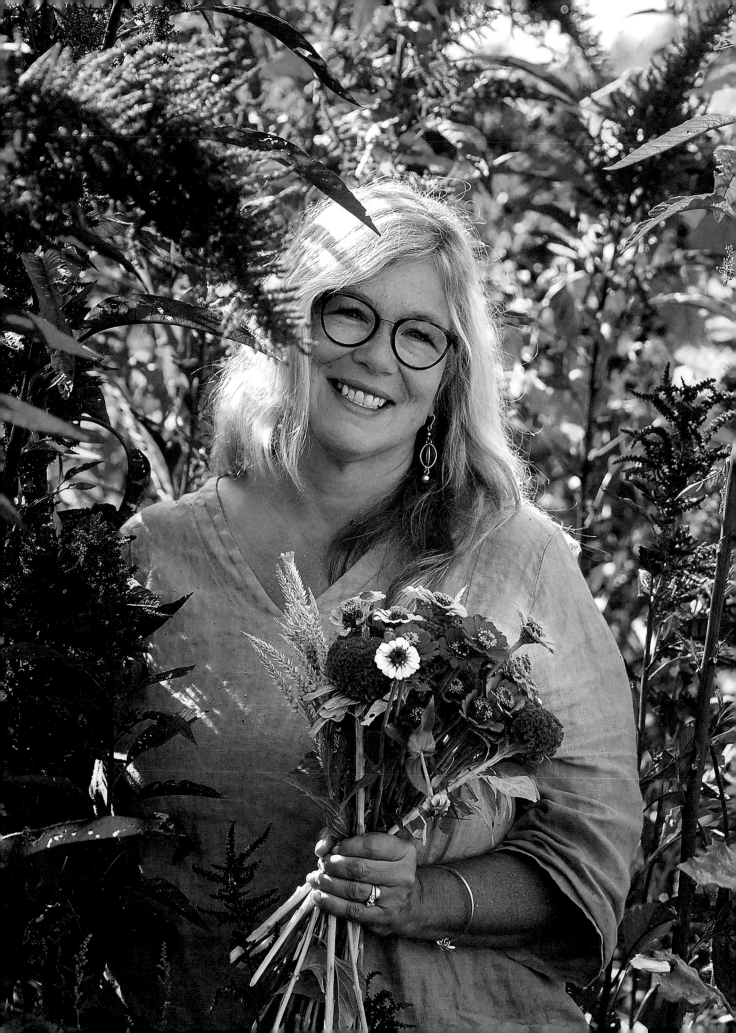

DISCOVERING HOPE

I used to wonder where the long gravel driveway led. Lined on either side with mature trees, its ultimate destination was hidden from view. For 28 years, I drove along Stumptown Road, past the picturesque entrance only a few miles from our home, wondering what was at the end. My imagination painted a vision of what I might find at the end of the lane. Little did I know that by taking a turn off the main road onto that driveway, the course of our future would be greatly altered.

When I learned there was a farm about to be sold at the end of that driveway, something inside me yearned to preserve it. Serendipity happened and Hope Flower Farm came into our hands in 2015, when Evan and I took a leap of faith and purchased the 25-acre property, once a dairy and pig farm. The acquisition fulfilled my long-held dream to own a gathering place to teach, produce events, support other artists, and stimulate tourism in our community.

Located in Waterford, Virginia, an unincorporated village in Loudon County outside of the nation's capital, this place takes everyone who visits back in time.

When I found Hope, I was in the midst of preparing for a very large wedding. With funds in the bank from this project, an angel investor also seemingly fell out of the sky. In one magical conversation, they told me, "I see what you've done in the industry, and I believe in you. Now, I would like to loan you enough funds to make the farm's down payment." This was a massive affirmation I was on the right course. I swore to my investor the farm would always have a service component of giving back. I made this commitment happen in the first year, and to this day, service is a core mission of Hope Flower Farm.

We decided to name our old-new possession Hope Flower Farm in honor of the family who had farmed there for 60 years,

PREVIOUS PAGES: The lawn adjacent to the Manor House at Hope Flower Farm is an ideal setting for a celebratory meal served beneath the shade trees. LEFT: Ruby red amaranths at Hope Flower Farm tower above Holly as she gathers blooms for a design project.

PHOTOGRAPHY BY CHRIS + CARLENE THOMAS

DISOVERING HOPE

"I HAVE BEEN TRAVELING THE WORLD OVER TO RETURN TO A LEGACY CALLED HOPE. I'M A FARMER'S DAUGHTER WHO BECAME A DESIGNER, WHO CREATED A LEGACY BY FOLLOWING HER ROOTS."

Maryellen and Howard Hope. We inherited the farm's agricultural buildings, all a bit worn, although no longer occupied by cows or hay. With these structures, I envisioned exactly how to transform the property.

We immediately began breathing new life into the barns, out-buildings, and houses dotting the idyllic landscape. Just three weeks after closing on the purchase we hosted our first Chapel Designers workshop and a Gregor Lersch Workshop.

We served lunch from the tiny kitchen inside the stone Quaker residence built in 1820, and students created their designs at worktables Evan built and painted the week before the workshops were held.

The historic stone residence, which we now call the Manor House, lives life anew. Its dining room, parlor, screened-in porch, and exterior doorways lend character to our editorial photography sessions, or serve clients who hire us to design and style for their brands. We have furnished the dining room with a long farm-style trestle table and select items from my cupboards and collections to set the table with linens, dinnerware, stemware, and candlesticks, not to mention flower vases.

The Tenant House was once home to Mr. and Mrs. Hope who managed the farm. Now in its new role, its cozy setting is favored by many of our speakers and students who enjoy sharing breakfast together in the morning or gathering on the screened-in porch after hours during the annual festival. The charming cottage on the property is also a registered Bed & Breakfast venue in our county.

As an education hub, Hope Flower Farm has allowed me to host amazing instructors including Gregor Lersch, Hitomi Gilliam, Robbie Honey, Sue McLeary, Ariella Chezar, Françoise Weeks, Steve Moore, and so many others. I knew there was a world beyond this self-taught place where I dwelled. I also knew if I wanted to fly higher, I needed to learn more. I needed to learn from the very best and the Farm gave us the space for this purpose.

Between the Tenant House and the Bank Barn, on the lawn, we've built a giant fire pit with a black iron cauldron. Logs form a seating circle, inspiring nurturing conversation and community for those who spend a few days at the farm attending workshops. The setting feels familiar and welcoming, especially as friendships are made and renewed, year after year. In the fields beyond the Tenant House, we occasionally erect luxury "glamping" accommodations for guests at Flowerstock, the annual festival held every October for flower aficionados. I love seeing our meadow dotted with the natural-canvas tents, each erected on its own wood floor,

Continued on page 135

The front porch of the Manor House has hosted many a late-night flower conversations, with tales shared among friends and guests. This is where the full potential of Hope is realized.

EMILY GUDE PHOTOGRAPHY

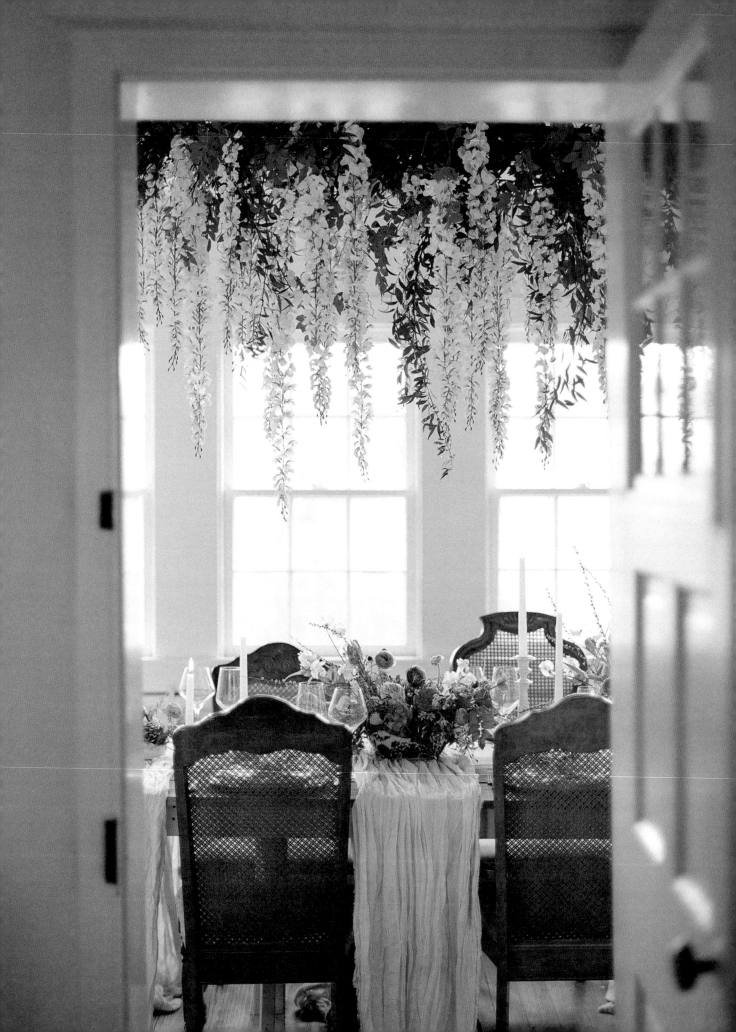

With its bright red siding, the Silo Barn is a perfect backdrop for the dahlia border.

LEFT: The dining room is a versatile space, allowing workshop students a stage when they select place settings and linens from the prop closet. ABOVE LEFT: Maryellen and Howard Hope were the tenant farmers on this land for more than sixty years. The farm was once called Strawberry Veil, but Evan and Holly honored their predecessors' life's work with the name often used by locals: Hope Farm.

LEFT: THEO MILO PHOTOGRAPHY; TOP + BOTTOM RIGHT: SARAH COLLIER PHOTOGRAPHY
BOTTOM LEFT: JODI + KURT PHOTOGRAPHY

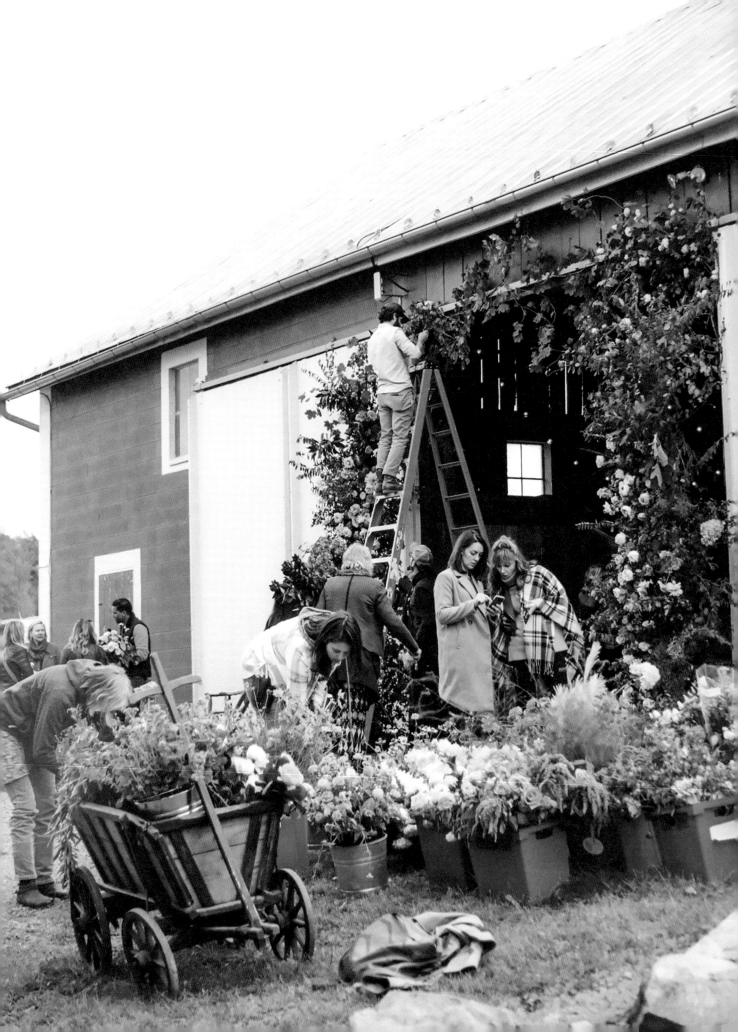

FLOWERSTOCK @HOPE

"THIS ONE-OF-A-KIND BOTANICAL FESTIVAL BRINGS TOGETHER HUNDREDS OF FLORISTS, GARDENERS, AND FLOWER LOVERS TO ENJOY TWO BLOOM-FILLED DAYS LEARNING FROM TOP DESIGNERS AND CONNECTING WITH KINDRED SPIRITS."

In 2016, Hope Flower Farm allowed me to create a different type of experience called Flowerstock. A hybrid between an educational workshop and a flower festival, Flowerstock took shape as my response to a market suddenly being flooded with lavish professional floral conferences that I found lacked meaning and purpose. As I conversed with designers at my conferences, I knew all we needed was to be together, to share ideas, and to dream.

I would joke with fellow designers and Chapel Designers about not needing anything fancy. We would be happy sitting together in a field of flowers talking about our businesses. As we imagined what this would look like, the simplicity of gathering in a "field of flowers" captured our imaginations and quickly became "Flowerstock."

This one-of-a-kind botanical festival brings together hundreds of florists, gardeners, and flower lovers to enjoy two bloom-filled days learning from top designers and connecting with kindred spirits. I wanted to offer everyone the opportunity to rub shoulders with rock star florists, to take a creative writing session, and to dine, al fresco-style, at farm tables edged by double borders of dahlias. The attendees make their way to Flowerstock from across the U.S. and Canada — and we have had flower lovers attend from as far away as Ireland, England, Scotland, Brazil, and Romania.

I make sure everyone attending wakes up to hot coffee and optional outdoor yoga before making their way to the Bank Barn where guest instructors demonstrate floral techniques beneath the vaulted ceiling, exposed rafters, and strands of café lights. I want to keep things intimate, ensuring presenters and guests can easily mingle with each other. Buckets for classes are filled from the garden, brimming with dahlias, zinnias, cosmos, amaranthus, sunflowers, ornamental grasses, cockscomb, scented geranium, gomphrena, foxgloves, nandina foliage, passionflower vine, and foraged greenery.

At the closing festivities our guests adorn their hats, heads, and shoulders with floral attire. They dine, family-style, on seasonal and local fare prepared by a local eatery and caterer — the very one who gave me my first commercial floral design contract when I started my business. There are all sorts of floral design workshops now moving in a luxurious direction, but in its simplest and most peaceful form, Flowerstock celebrates a genuine passion for flowers. It always will.

Attendees of the 2018 Flowerstock at Hope Flower Farm participated in a hands-on "flowering" of the Bank Barn's entrance, an activity led by design instructors Alicia and Adam Rico of Bows + Arrows.

SARAH COLLIER PHOTOGRAPHY

FLOWERSTOCK @HOPE

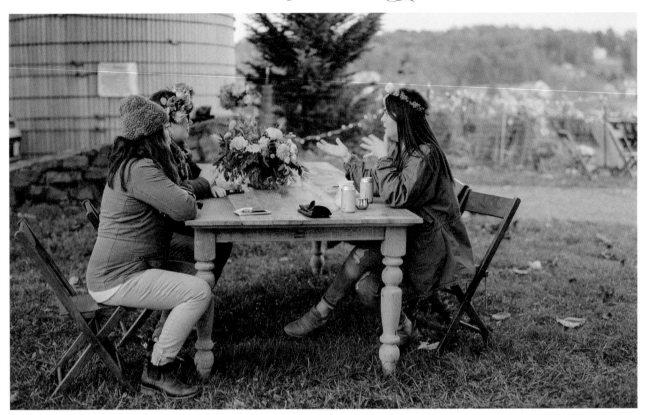

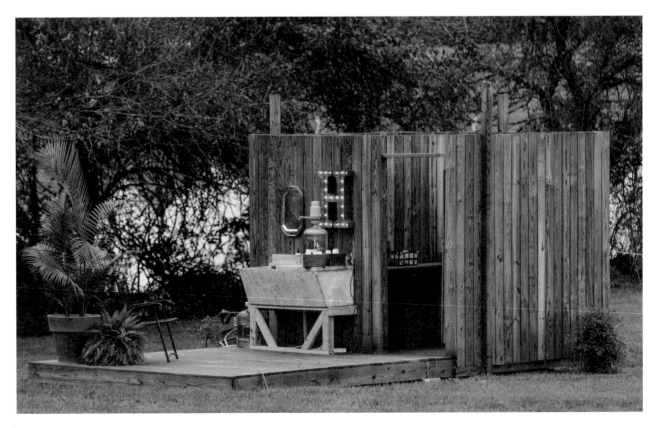

Flowerstock guests gather on the lawn where informal connections and conversations are as rewarding as the educational sessions; the outdoor shower house, designed and constructed by Evan, and used by attendees who stay overnight in canvas tents.

SARAH COLLIER PHOTOGRAPHY

FLOWERSTOCK @HOPE

A Flowerstock tradition invites guests to design unique floral crowns, hat bands, and headpieces to wear during the final evening's festivities. CLOCKWISE FROM TOP LEFT: Karen Pacific and Teresa Kinder of Artful Blooms; Elodie Perrier, a French artist, florist, and one of Holly's former interns; Chapel Designers Maggie and Mick Bailey of Bramble & Bee; and Lauren Garza of Flora + Fauna.

SARAH COLLIER PHOTOGRAPHY

FLOWERSTOCK @HOPE

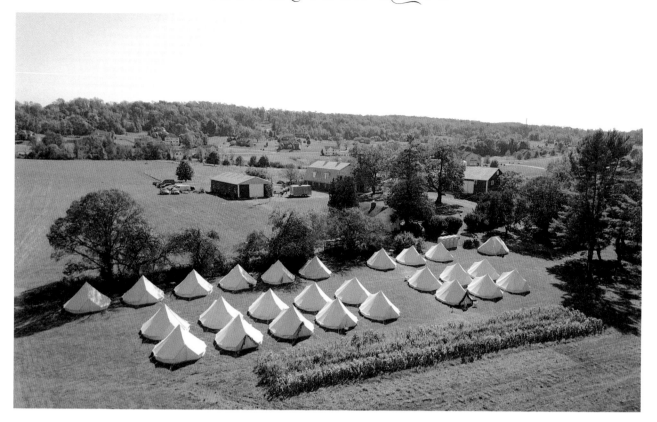

ABOVE: Canvas "glamping tents" dot the fields and create a jovial, instant village during Flowerstock;
many attendees personalize their temporary abodes with flowers, vines and ribbons.
RIGHT: Beneath strands of café lights, Flowerstock guests dine on wooden farm tables built by Evan.

KIR2BEN PHOTOGRAPHY (TOP AND RIGHT); SARAH COLLIER PHOTOGRAPHY (BOTTOM)

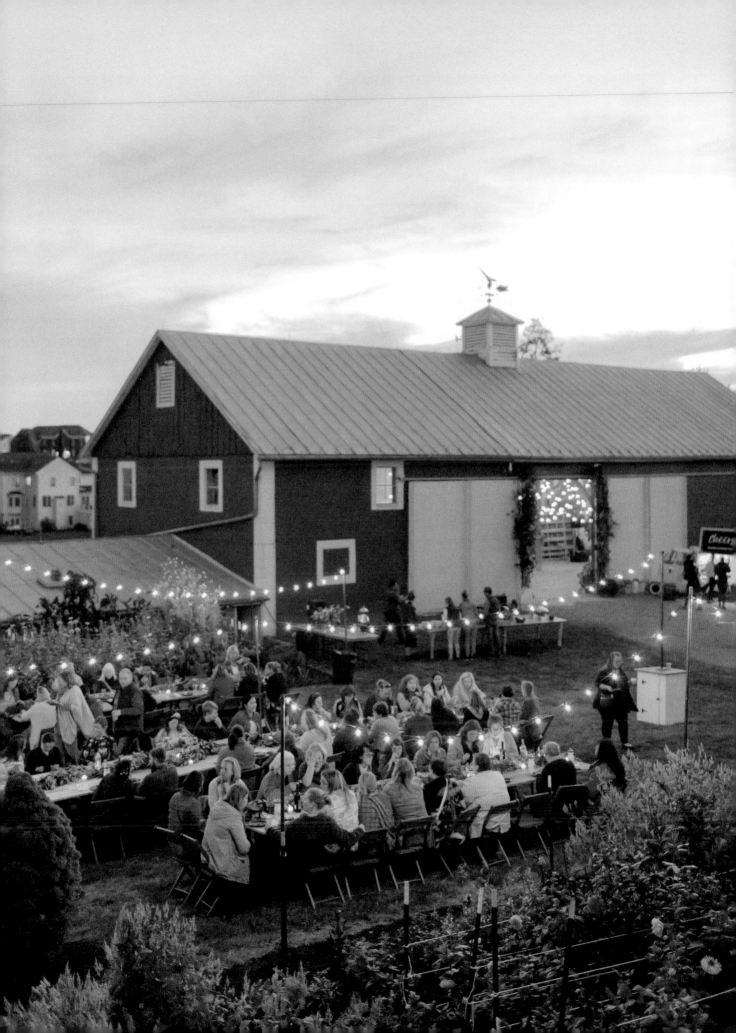

At Hope Flower Farm, the Flora and Fauna Fashion Show benefits pediatric cancer charities. LEFT: Valerie Powell carries carries a whimsical floral bouquet. RIGHT: Parie Donaldson models a bouquet, cuff, and tattoo designed by Cassandra Shah.

LEFT: Sharon Rude models a floral necklace, purse, parasol, and rings by Cathy Seeliger.
RIGHT: Lindsay Diminick wears a headpiece by Angela Stoffregen.
FAR RIGHT: Valerie Powell models an extravagant floral headpiece and purse designed by Holly.

SARAH COLLIER PHOTOGRAPHY

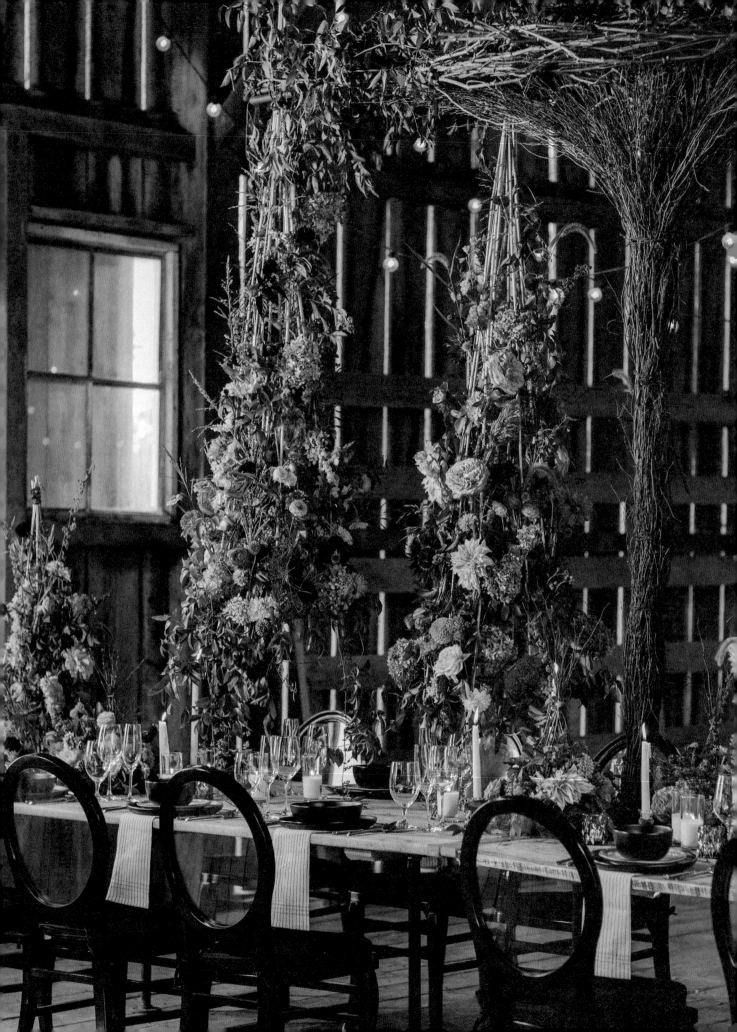

WORKSHOPS @HOPE

Here at the farm, I've hosted one-on-one intensive classes, smaller workshops for garden clubs and aspiring florists, flower festivals for the local community, and larger, multi-day workshops.

As it happens, Gregor Lersch came to Hope Flower Farm to teach workshops barely three weeks after we closed on its purchase. I couldn't jet off to Germany to study with Gregor, but I could bring him to me. Hosting world-class teachers has given me the opportunity to build relationships with amazing people. I learn as much from them as everyone else does.

> "HOSTING WORLD-CLASS TEACHERS HAS GIVEN ME THE OPPORTUNITY TO BUILD RELATIONSHIPS WITH AMAZING PEOPLE."

Gregor basked in being here, because it was such a contrast to teaching in a commercial space. He told me, "This farm is a dream, this house is a pearl, and this will be one of the finest schools of floristry." His affirmation meant the world to me. I think we're cut from the same cloth and share a sense of integrity, responsibility, workmanship, drive, and passion. In all dimensions, we're kindred spirits.

 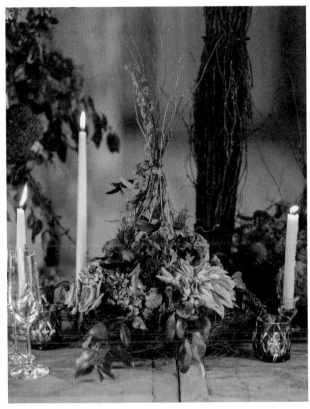

World-class floral designer and educator Gregor Lersch has traveled to Hope to teach on many occasions. His remarkable workshops introduce students to his European styling and mechanics and elevate everyone's floral technique. Gregor's large-scale installation incorporates bright tones and birch armatures that hang above the tables where students dined following the workshop.

THEO MILO PHOTOGRAPHY

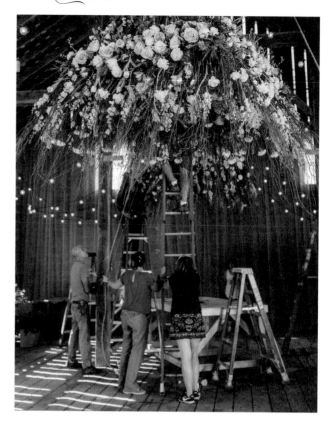

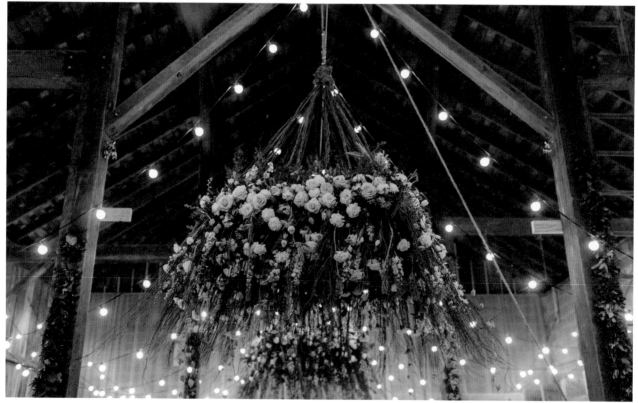

A Gregor Lersch chandelier workshop introduced a new level of large-scale event design
and incorporated hanging structures designed and welded by Gregor and Evan.
These beautiful pieces still hang in the Bank Barn.

VICTORIA HEER PHOTOGRAPHY

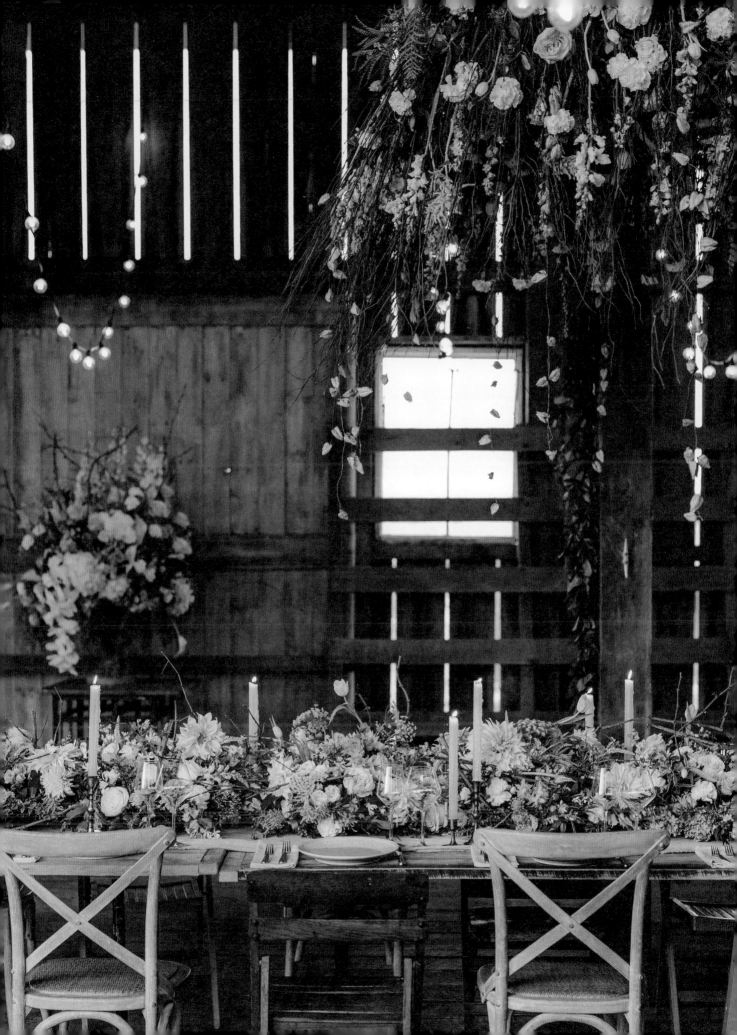

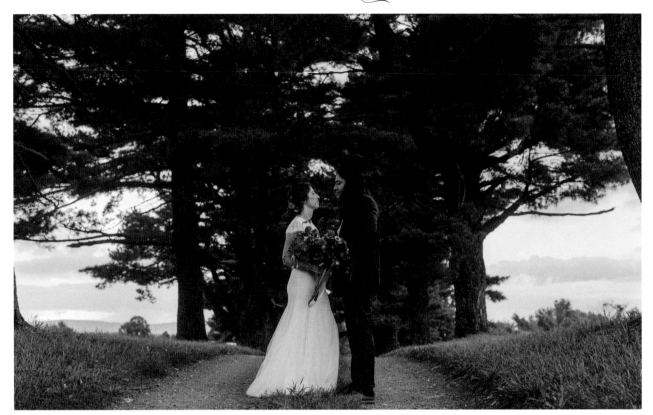

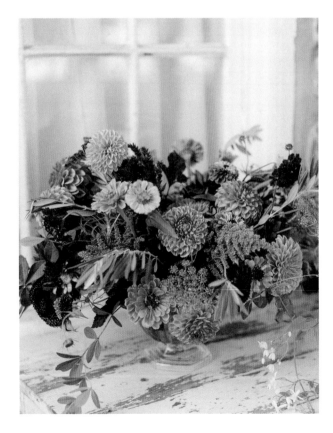

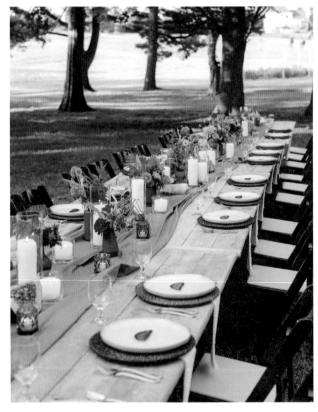

The smaller weddings Hope Flower Farm hosts always incorporate flowers and foliages grown on site.
This dreamy ceremony was designed and styled by Holly and her team,
while guests dined on the farm tables designed and built by Evan.

EMILY GUDE PHOTOGRAPHY

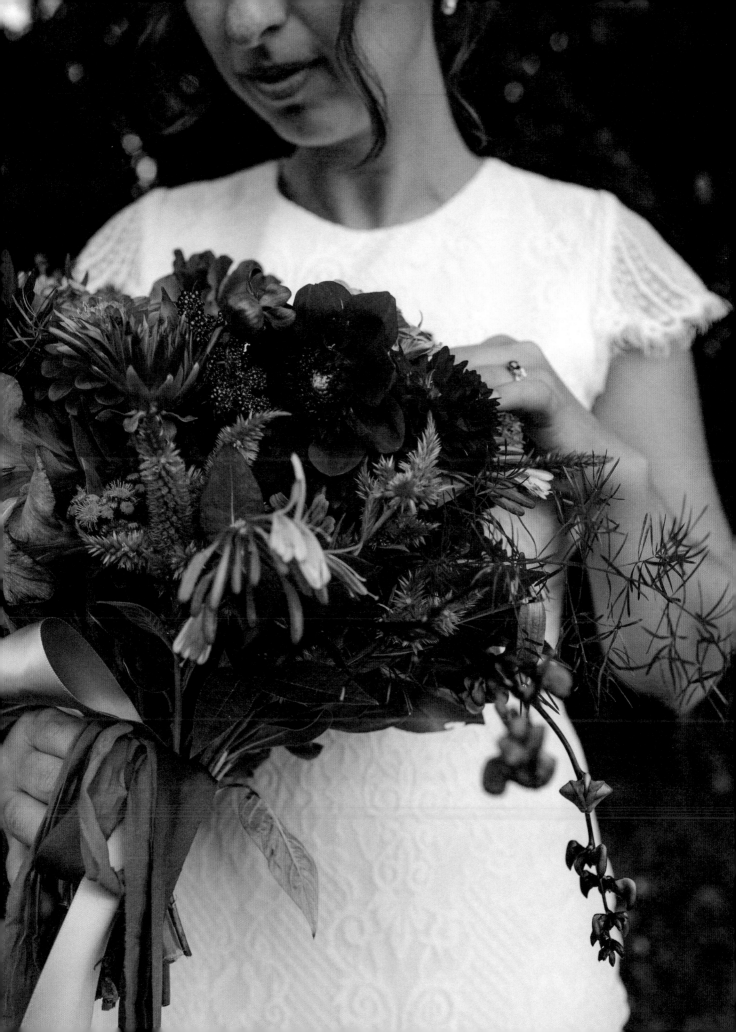

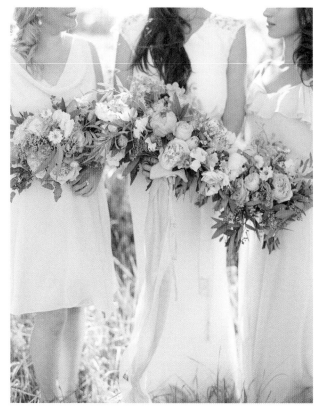

These designs are from a Hope Flower Farm workshop with guest instructor Robbie Honey. Students executed designs for a full-throttle photo shoot, including personal wedding flowers and a floral structure installed, canopy-like, above a well-dressed table. Holly and Evan's youngest daughter Grace loved modeling as the flower girl.

JODI + KURT PHOTOGRAPHY

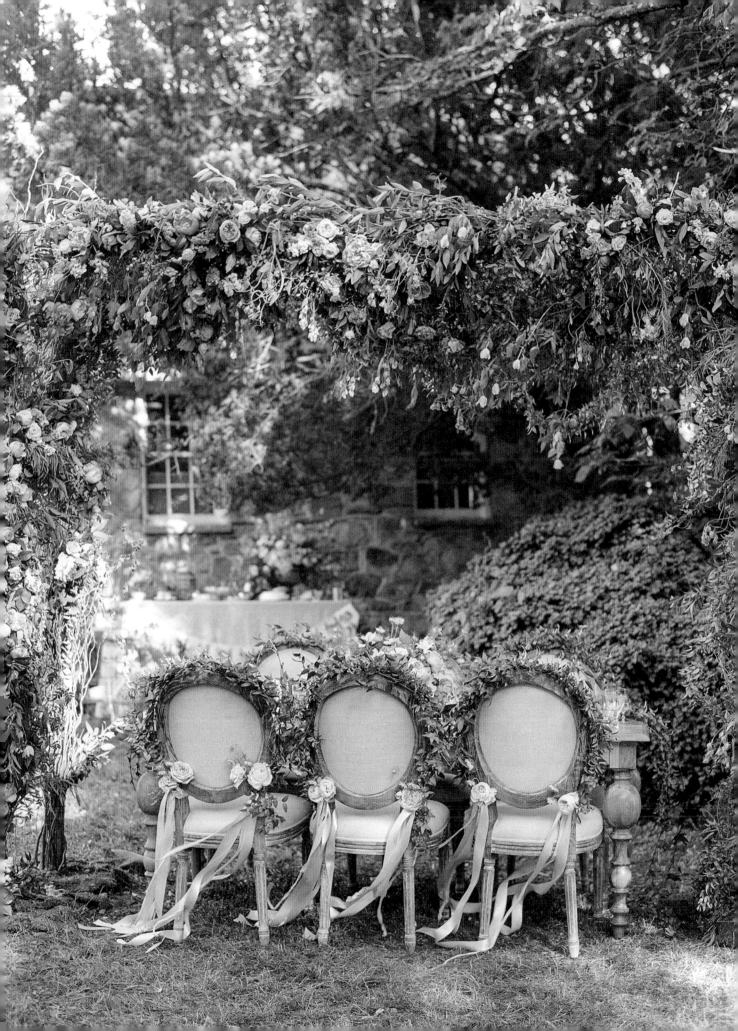

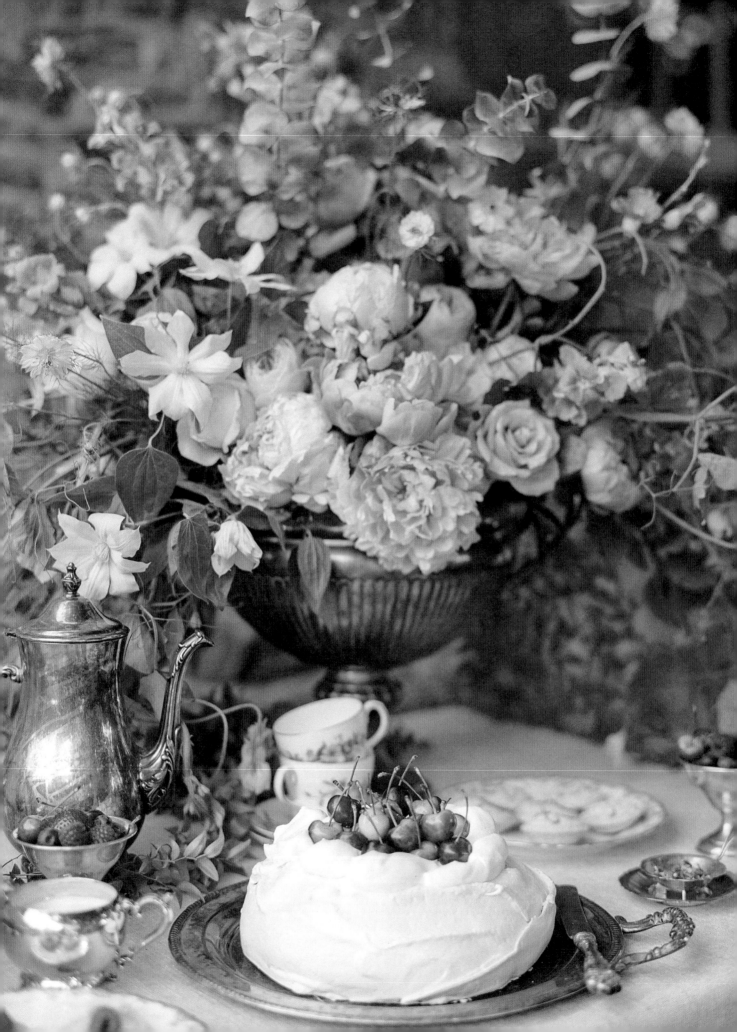

"THE MANOR HOUSE REMINDS ME OF MY CHILDHOOD FARMHOUSE AT LEGACY. A PINK DOGWOOD AND A CHERRY TREE WERE PLANTED IN HONOR OF MY PARENTS, AND A LITTLE GIRL NAMED HEIDER WALKS THE PEONY FIELDS AND WATCHES AS THE WHOLE WONDERFUL STORY PLAYS OUT AGAIN."

Continued from page 114
creating a charming village scene. We encourage guests to decorate the exteriors of their temporary homes, personalizing the shelters with flowers, streamers, and lanterns. A short path leads from the glamping field to the outdoor shower, complete with a privacy curtain, marquee lighting, and plenty of hot water, all designed and built by Evan, of course.

The Bank Barn hosts larger gatherings of up to 120 persons, and while massive in scale, its atmosphere feels wonderfully comfortable and inviting. Sunlight seeps through gaps in the barn wallboards, a rolling door when opened offers views of hilly vistas, and volunteers carry just-picked flowers harvested from Hope Flower Farm's borders and cutting garden, arranging them within easy reach of the presenters.

Overhead, the beams hold strings of festival lights and rigging suspends large floral sculptures. One of my favorite Bank Barn experiences is when we invite musicians to perform. Dancing often continues well into the evening and the acoustics are perfect. For many reasons, this setting makes so many people so very happy.

There's also the Silo Barn, a two-story edifice crowned with a distinctive metal silo. Upstairs, we've created an inviting space to provide an additional instruction area. Teachers demonstrate floral techniques beneath the vaulted ceiling, yet the space feels intimate when attendees are encouraged to pull their seats close to the presenters and mingle with each other.

The lawn between the two larger barns is edged by deep borders of Hope Flower Farm dahlias and summer annuals exploding in joyous color. When we serve farm-to-table meals and I see all our friends and guests gathered together here, laughing, singing, experiencing nature under the summer sky, the beautiful scene takes my breath away. It's exactly what I dreamed about and envisioned would happen here.

Most recently, we transformed Evan's Barn into the Studio Barn, a climate-controlled workshop, complete with dedicated walk-in flower cooler and a floral photography studio for editorial projects and product development. The interiors of the barn are finished with white shiplap, while iron chandeliers hang from the corrugated metal ceiling. The practical worktables lend a multipurpose efficiency. From my perspective, I love the intimacy of teaching small-group workshops in this space. It's also perfect for the small weddings and gatherings we have held there. It's just so intimate and pretty.

A lovely tablescape detail from the Robbie Honey workshop showcases peonies, clematis vines, nigella and roses that coordinate with vintage china and silver serving pieces.

JODI + KURT PHOTOGRAPHY

DISCOVERING HOPE

"I WANT AND NEED PEOPLE TO KNOW THE POWER OF OUR SWEET OLD DAIRY FARM. I WANT OUR GUESTS TO EXPERIENCE THE BEAUTY OF ITS FLOWERS. I AM ENJOYING EACH NEW ENDEAVOR, AND IT'S GRATIFYING FOR ME TO OBSERVE PEOPLE'S DELIGHT AS THEY INVESTIGATE THE FARM."

Our flowers are at the core of all our activities here at Hope Flower Farm. It's what makes us special, and our customers know and treasure this. You have to really care about flowers; they have to be an important part of your event or you're going to miss the value in what this farm offers.

Through its renovation, the farm has inspired joy for so many reasons, including one I never anticipated: seeing everything once purposeful, once functional, revive and come back to new life. Suffice it to say, because I consider Hope a calling for myself, my family, co-workers, students, and visitors, the farm gives us a physical place and space to express this life pursuit. It's a source of huge joy as we share this thriving place of creativity, collaboration, and community with others.

As we continue to sink our roots deep into the soil of this precious place, it has become more than a floral destination for conferences, workshops, festivals, and one-on-one educational classes. It's now a working flower farm with the fields and hoop houses expanding to supply bodacious blooms for the design studio and for local fans to discover in the retail space.

Considering everything, Hope Flower Farm has achieved my goal to create a destination for all those who love flowers. Whether people come here to learn about growing flowers or designing bouquets, attend one of our special events, or take a tour, Hope Flower Farm gives us an opportunity to sustain a livelihood from the land. This is a different type of agriculture. All of my key influences began — and still begin — in the garden, and I now embrace a deeper relationship with the land thanks to Hope Flower Farm.

I have also learned we do not possess Hope Flower Farm; we are possessed by it. It fascinates me to remember how we were so afraid of taking the risk to pursue buying this farm. Considering how beautifully everything has come together, I believe this farm provided an amazing opportunity to stretch and grow my vision and our business, from flowers to education, to becoming the singular focus of Holly Heider Chapple Flowers.

Once upon a time I used to say Holly Heider Chapple Flowers had a heart and a soul, but no permanent address. Now it does. In its entirety, this farm has given everyone involved the opportunity to gain experience in ways none of us ever imagined. It's the source of constant inspiration to me as a designer and at the heart of every concept and idea I dream up. I can humbly say it's an honor to be the steward of a farm called Hope.

Like a secret room in a wild, overgrown bower, this storybook scene is a reminder of Holly's belief that the answer is always in the garden.

ANNE ROBERT PHOTOGRAPHY

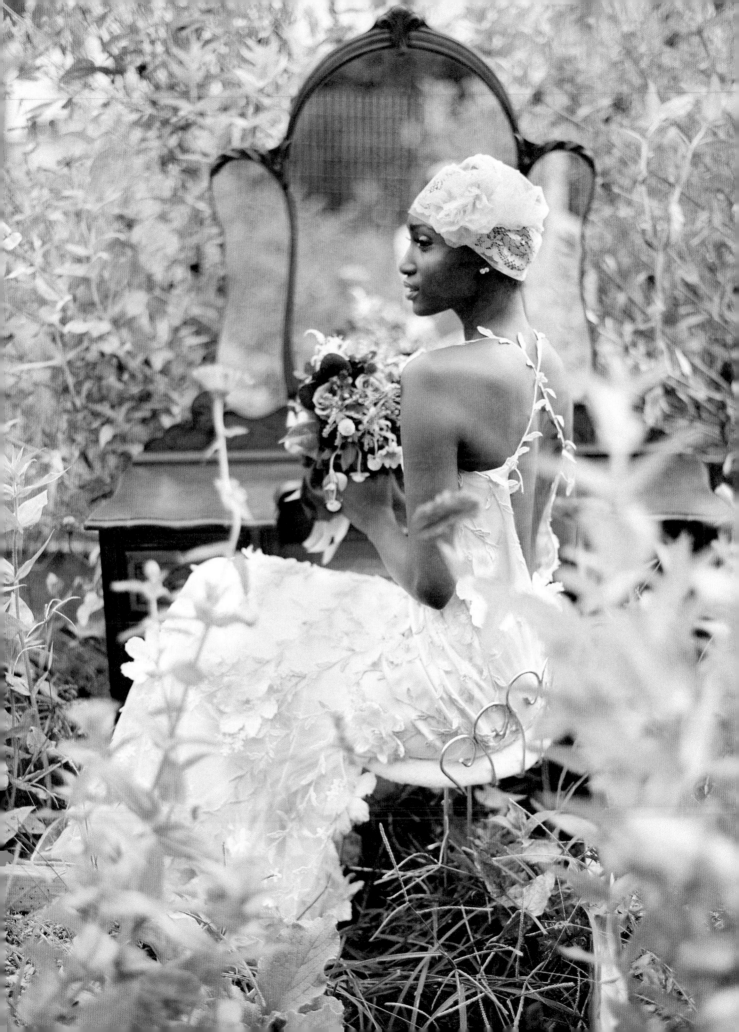

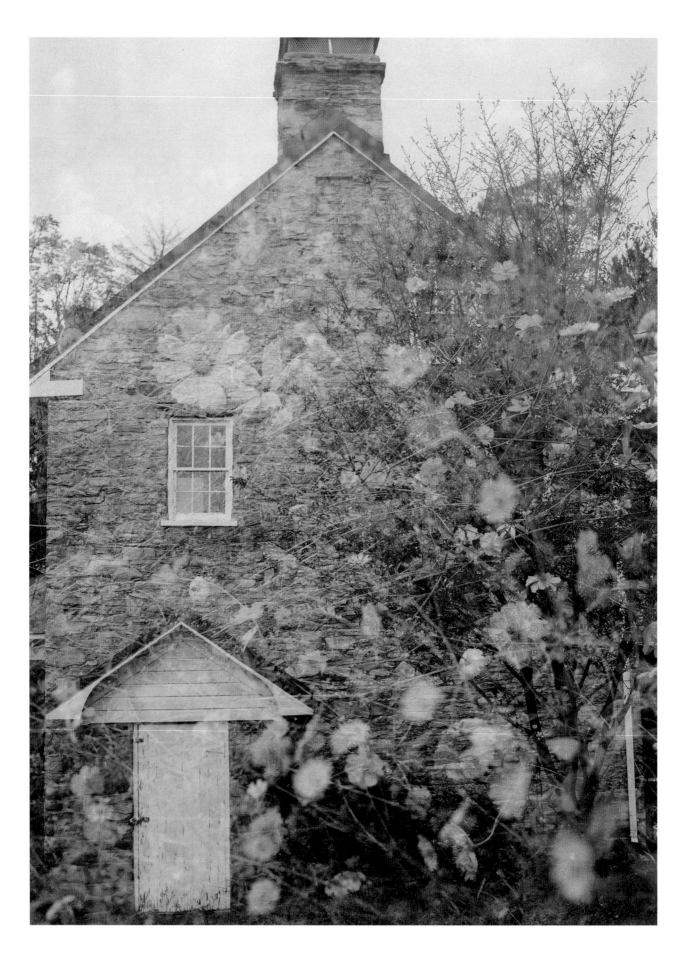

ACKNOWLEDGEMENTS

How do I possibly begin to thank and acknowledge all of the people who have wholeheartedly encouraged my growth and "fertilized" my true potential? Each person I've encountered and each place I've flowered has played a significant role in my life and added to my story. I carry with me countless heartfelt memories of so many flower friends and flowering episodes.

Our flower story began with a focus on our family. I have endless gratitude for my husband and business partner Evan Chapple. He and our seven precious children have allowed me to be a wife, a mother, an entrepreneur, and a traveling floral educator — known as the "flower mama" to the floral industry. To Alex, Abigail, Hannah, Riley, Elijah, Samuel, and Grace — you are our extraordinary children and your father and I are so proud of each of you.

For many years I provided flowers to my community for weddings and festivals. However, my story gained momentum and became profoundly rich with the development of social media. Through this new medium, I connected with people who truly became my tribe, my lifelong friends and colleagues, many of whom are Chapel Designers. During this time, I discovered my

"WHEN I VISUALIZE MY LIFE AND ITS RELATIONSHIPS, I SEE A CHAIN. ONE LINK IS A PERSON'S STORY, OR A FLOWER, AND IT CONNECTS TO THE NEXT PERSON OR STORY. IN THIS WAY, THROUGH EACH CONNECTION, WE CONTINUE ON AND ON, HELPING EACH OTHER GROW."

voice and embraced my role as a supporter and encourager of those longing to live their lives with flowers. I became friends with Amy McGee from Botanical Brouhaha. Her belief in me and her promotion of my work was vital as I embarked on my floral journey. She was there, behind the scenes, directing designers and wedding and event florists to me, nurturing my new business. Many of them ultimately became Chapel Designers, and for this I will always be thankful.

With absolute certainty, it is this community of Chapel Designers to whom I owe a special thanks. For all of you who created and changed the world of flowers with me, I have deep love and gratitude. By building our community, we changed not only the profession of floristry but also the wedding industry. We taught photographers, planners, and the industry at large, how colleagues could come together to share knowledge and support rather than competing with each other.

A very special thanks to Chapel Designers Isha Foss, Susan McLeary, and Alicia Magnier. My relationship with each of you has endured through many challenges and you are cherished constants in my life.

SARAH COLLIER PHOTOGRAPHY

ACKNOWLEDGEMENTS

Widening my scope of gratitude, I must thank David Beahm for hosting this country girl in New York City and for being a devoted educator and friend of the Chapel Designers network. Thank you also to Nick Priestly for seeing the potential of Chapel Designers and for expanding the organization internationally. To the many educators and floral superstars who have taught by my side and enhanced the world of floristry via our conferences and workshops, I thank you. Thanks to my friend Françoise Weeks who left the land of an introvert to become this outgoing girl's friend. Together, we found the courage to pursue our dreams.

Thank you, Gregor Lersch and your lovely wife Gaby, both for sharing your expertise and time with me at Hope Flower Farm and for inviting us to your home in France. Your investment and belief in Evan and me are among our greatest gifts. Thank you to Hitomi Gilliam for seeing the strengths and exceptionality in every designer and for helping us each become our best. I will forever remember how you supported me and so many others; you are the truest of true.

I also want to acknowledge how every floral creation, every small and large aspect of our business, is greatly impacted by the many designers and staff members who have worked for Holly Heider Chapple Flowers (Team HHC). I thank everyone for your countless hours of bucket washing, ladder hauling, flower processing, and extraordinary artistic design. You have truly made this business thrive. My special thanks go to Sydney Chapman as the most remarkable addition to our brand. Thanks also to my son Alex who runs our online school and gives to a distinct community he envisioned by founding The Greenhouse. Thank you to Megan Pollard for walking through fire with me and always helping me aim for the stars.

Add applause and thank-yous to my partners at Syndicate Sales, including Laura Shinall, Anne Graves, and Trent Harshman. You took my vision for a sustainable product line and built a collection of floral tools and accessories to empower designers and encourage revolutionary changes in the profession. Together, we've created floral essentials found now in every designer's toolbox.

Thank you to the photographers who have so kindly shared their beautiful images collected in these pages. When captured through their lenses, I know our creativity and floral art becomes magic. My special thanks goes to Abby Jiu and her team, Sarah Collier, and Jodi and Kurt Miller for going far beyond expectations in providing images. Also, a heartfelt thank you to Emily Gude for our cover photograph. Without your documentation of my life's work, this beautiful book would not have been as complete.

For bringing this book to reality, I give a specific thank-you to Debra Prinzing and Robin Avni. This book could not have happened without you. I so needed your focus and devotion to this project, because I know my story would not have been told otherwise. You have beautifully documented a special journey and my life in flowers.

ABOUT HOLLY

O NCE UPON A TIME, A YOUNG MOTHER NAMED

HOLLY HEIDER CHAPPLE FOUNDED A SMALL WEDDING AND

EVENT DESIGN BUSINESS.

A dedicated mother of seven, a wife, and an entrepreneur, Holly is the creative visionary behind Holly Heider Chapple Flowers. A longtime resident of Loudoun County in Virginia, Holly is a highly recognized floral designer whose work has appeared in countless prestigious publications such as Martha Stewart Weddings, The Knot, Brides, Southern Living Weddings, Inside Weddings, and In Style, along with countless wedding blogs. She was chosen by Martha Stewart Weddings as a top wedding florist. With more than 28 years of experience, Holly now serves as a teacher, speaker, and mentor for other professionals in the wedding industry. She established the Chapel Designers (a division of HHC) in 2010 as an international collective of wedding and floral event designers who she mentors and educates.

Holly is a panel member of the American Floral Trends Forecast and Trend Summit. She has taught floral design education across the U.S. and internationally in Russia, Australia, China, England, Scotland, Ireland, Belgium, Ecuador, and Canada. In July 2018, Holly was invited as a main-stage presenter at the American Institute of Floral Designers Symposium in Washington, D.C. As an established floral association, AIFD recognized Holly, who is not AIFD-certified, for her talent and contributions to the floral profession.

With her husband Evan Chapple, Holly founded Hope Flower Farm in 2015 as a center for floral education and innovation. Hope is a functioning flower farm and also operates as a bed and breakfast for floral designers. The flowers grown at Hope elevate Holly's editorial work, supplement clients' designs, and enhance the experience of in-person educational offerings.

In 2018, Holly partnered with Syndicate Sales to launch her own product line of sustainable floristry tools and containers. She continues to influence trends in the profession and is known for the elegant and beautiful garden-inspired designs that leave her studio. Based on her unique sense of style, the term "Hollyish" emerged as a way that peers and clients alike describe her design aesthetic.